DOVER,
NEW HAMPSHIRE
THROUGH TIME

THOM HINDLE COLLECTION

AMERICA
THROUGH TIME®
ADDING COLOR TO AMERICAN HISTORY

Cover Photo: The Morrill horse trough fountain was a gift to the city of Dover in 1914 by the heirs of Joseph Morrill. In 1981, after Franklin Square was revitalized, the fountain was reconditioned and is now the focal point of Franklin Square.

Introduction photo: In 1675, the William Damm garrison house was built in the Back River section of Dover. It was moved in 1915 and is currently being preserved at the Woodman Museum.

America Through Time is an imprint of Fonthill Media LLC
www.through-time.com
office@through-time.com

Published by Arcadia Publishing by arrangement with Fonthill Media LLC
For all general information, please contact Arcadia Publishing:
Telephone: 843-853-2070
Fax: 843-853-0044
E-mail: sales@arcadiapublishing.com
For customer service and orders:
Toll-Free 1-888-313-2665

www.arcadiapublishing.com

First published 2020

Copyright © Thom Hindle 2020

ISBN 978-1-68473-001-8

Typeset in Mrs Eaves XL Serif Narrow
Printed and bound in England

Introduction

Dover, New Hampshire, the oldest continuous settlement in the state, was settled at Dover Neck in 1623. These early settlers were fisherman and members of the Fish Guild of Plymouth, England. The waters of the Piscataqua, Cochecho, and Bellamy Rivers proved to be very favorable for their venture, as they were filled with herring, cod, salmon, and beds of clams and oysters. In addition, there was an abundance of high-grade lumber and the forest was filled with fur-bearing animals. It was the ideal place to establish a settlement.

As early as the 1650s, a small shipbuilding industry began to grow along the Piscataqua River that connected with the ocean downriver. Eventually, river clay saw the establishment of brick yards that would flourish into the early 1900s. As settlers moved inland and upriver, waterfalls became a source of power, and sawmills, grist mills, and eventually textile mills were changing Dover into an industrial community. By 1830, the Cocheco Manufacturing Company would become a leading manufacturer of cotton cloth, and by the 1890s, the operation would cover over 30 acres of floor space, operating 130,000 spindles on 2,800 looms with a labor force of over 2,000 workers. When the mills began to move south where the cotton was grown, many of the old mills converted to shoe manufacturing. Today, the Cocheco Cotton Mills and the Sawyer Woolen Mills have been repurposed into residential and commercial space.

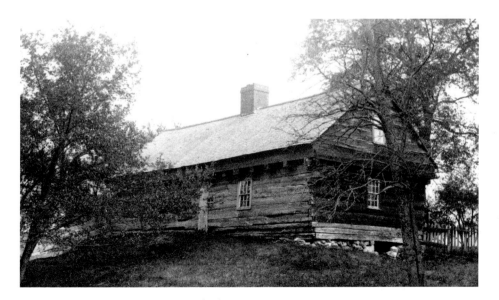

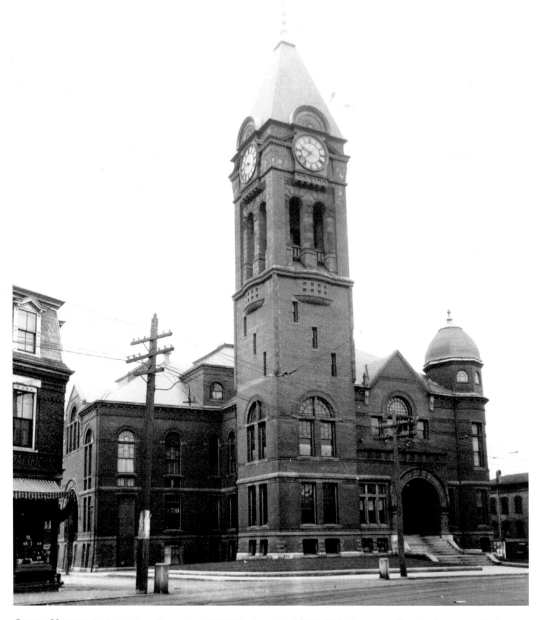

OPERA HOUSE: Dedicated on December 16, 1891, at a cost of $175,000, Governor Charles Sawyer called it "The People's Palace." The building served as Dover's third City Hall building with a police station in the rear.

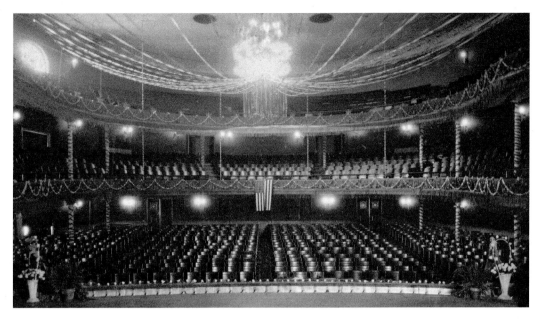

PEOPLE'S PALACE: The City Hall Opera House featured a seating capacity of 1,800, with a rising-falling floor and three-tiered balconies with velvet curtains and brass rails. Moving pictures were featured in 1896. In addition to the big names like John Phillips Sousa and Edwin Booth, many of Dover's local talent performed in school plays and minstrel shows. Unfortunately, on the morning of August 3, 1933, a fire destroyed one of the finest municipal buildings in New England.

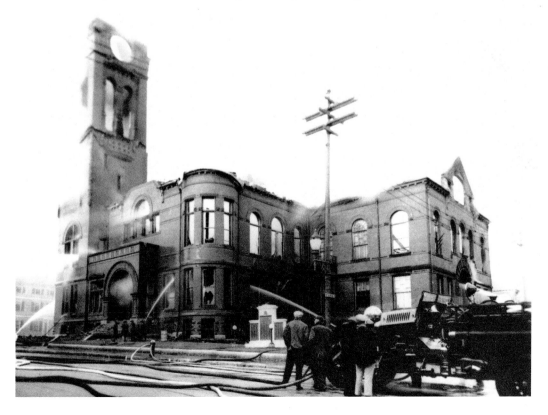

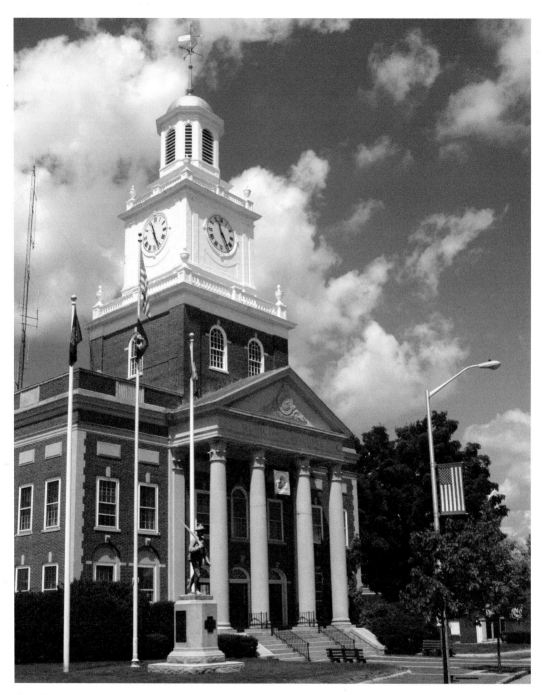

CITY HALL: The Georgian Colonial-style building was designed by Dover architect J. E. Richardson. One million bricks and 190 tons of steel were used to build a fireproof City Hall, with sixteen fireproof vaults to protect city records at a cost of $300,000. Many interior and exterior renovations have been made in recent years, including council chambers.

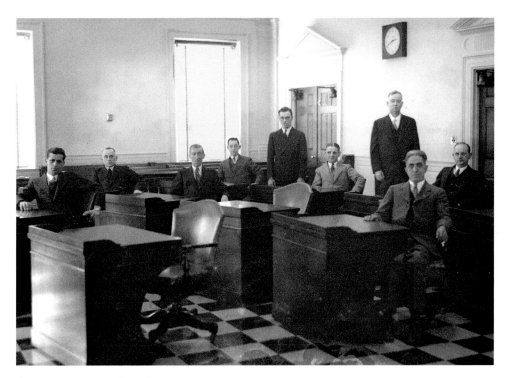

MAYOR KEEFE AND CITY COUNCIL: Mayor Clyde Keefe and council members pose in the council-alderman chamber after the December 1935 City Hall dedication. J. E. Richardson designed and created blueprints for the new construction.

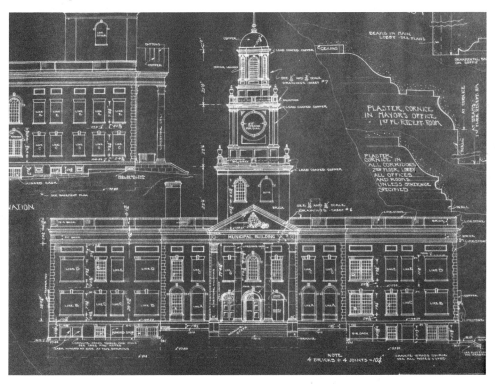

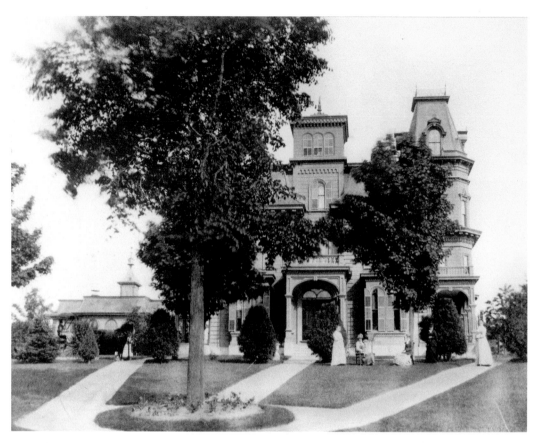

SAWYER MANSION: Jonathan Sawyer built this twenty-six-room home in the 1870s at a cost of $250,000. The tower was added in 1885. The home featured stables, a carriage house, fruit orchards, and greenhouses with exotic plants on seventeen acres. It was torn down in 1958 during construction of the new Spaulding Turnpike to make room for a Howard Johnsons restaurant and then a Burger King.

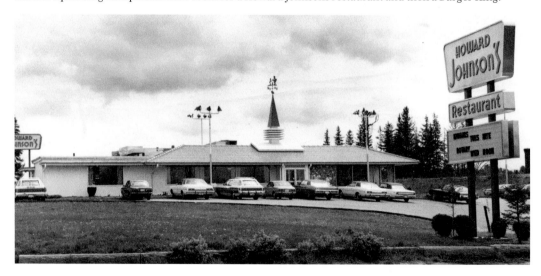

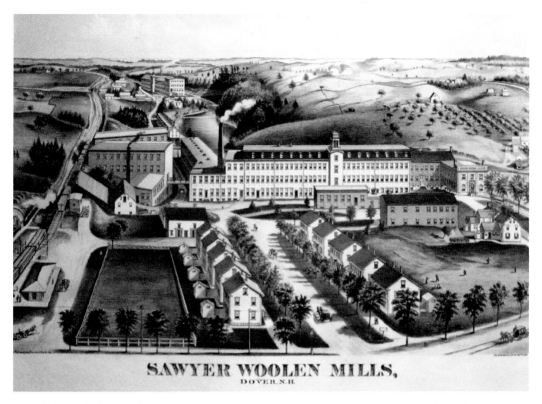

SAWYER WOOLEN MILLS,
DOVER, N.H.

SAWYER WOOLEN MILLS: After Alfred Sawyer's death in 1849, sons Francis and Jonathan operated the mills. During the Civil War, woolen products were being produced for the Union Army. The mills were acquired in 1899 by American Woolen, and in the 1960s, the mills became one of the area's first factory outlet stores. Today, the entire complex features modern apartments.

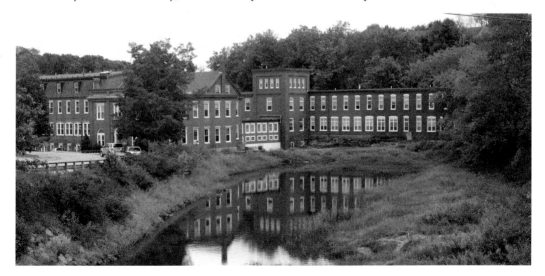

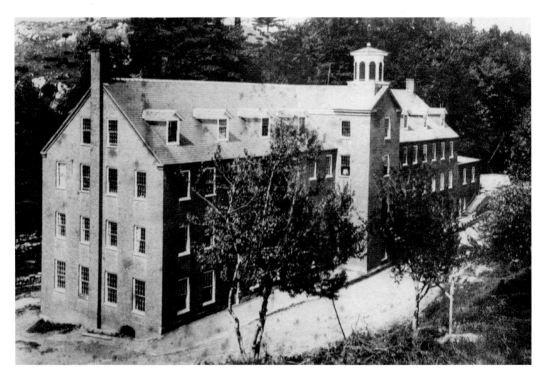

DOVER FILM: Located in the Sawyer's lower mill after World War II was a film company owned by Isadore and Benjamin Mark, which produced roll film for cameras. In the 1950s, a plastic 620-roll film Dover camera was offered. They also owned the Keystone Toy Company in Boston. Later in the 1980s, Holmwood's Furniture produced unfinished wood pieces and today the building offers modern apartments.

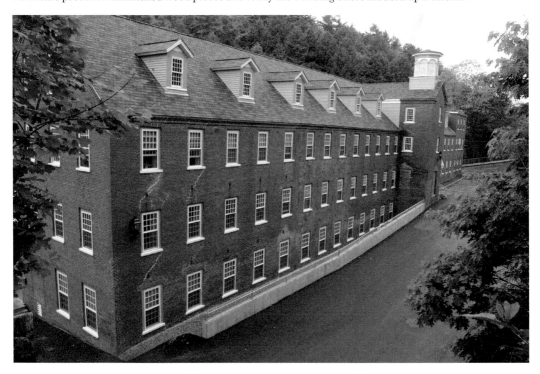

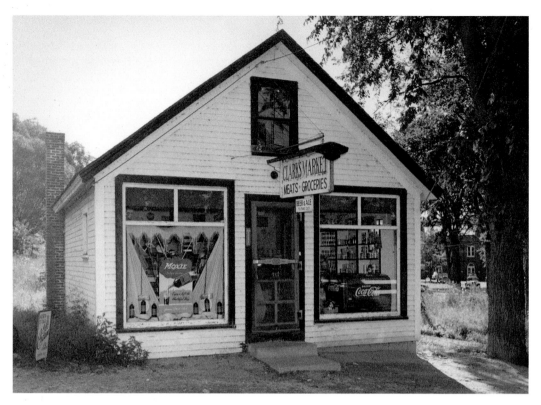

CLARK'S MARKET: John Clark opened this neighborhood store in the 1930s on the corner of Mill Street and Central Avenue near the Sawyer Mills. Today, Aroma Joe's offers fresh hot coffee. The Clark's Market photo was taken in 1951.

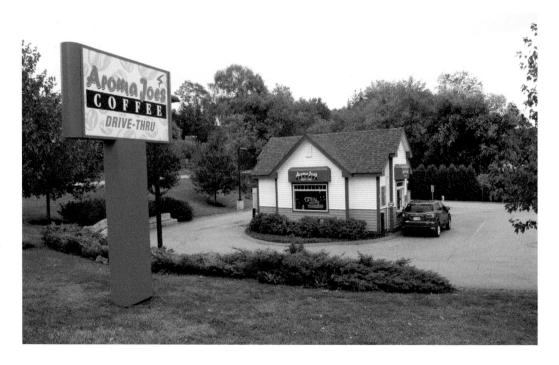

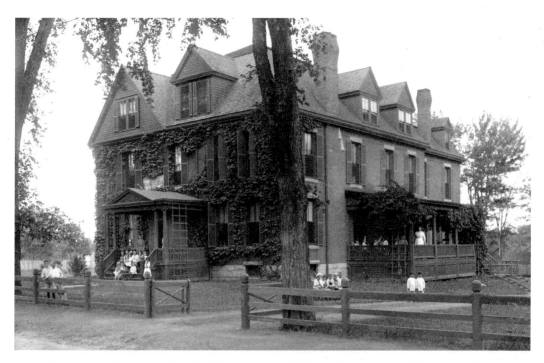

CHILDREN'S HOME: On May 10, 1893, the Dover Children's Home was established to assist destitute children. The original home was located on Atkinson Street with thirteen children, before moving to 11 Spring Street and growing to twenty-eight children. The current building on Locust Street was dedicated in 1897. As many as sixty children occupied the home during the depression. In 2018, the home celebrated 125 years of service, and today the home serves as an Intermediate Group Home for abused or neglected adolescents.

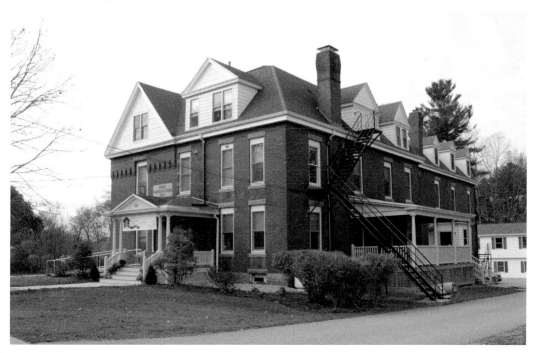

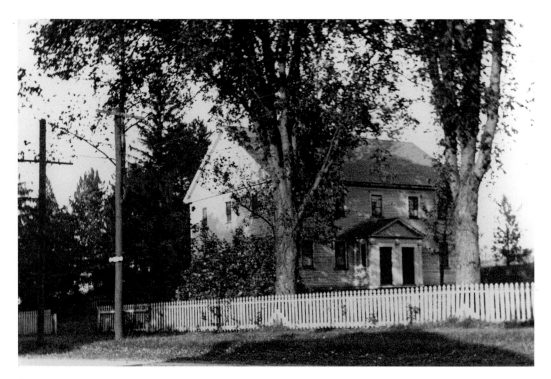

FRIENDS MEETING HOUSE: Built in 1768, the Friends Meeting House is the oldest church building in Dover. The first meeting of the Society of Friends was at Dover Neck around 1680. In 1804, the parents of poet John Greenleaf Whittier were married here. The current building was raised in 1989 to create a basement adding additional space and classrooms.

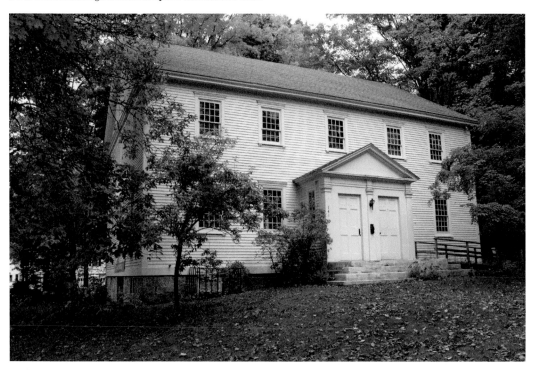

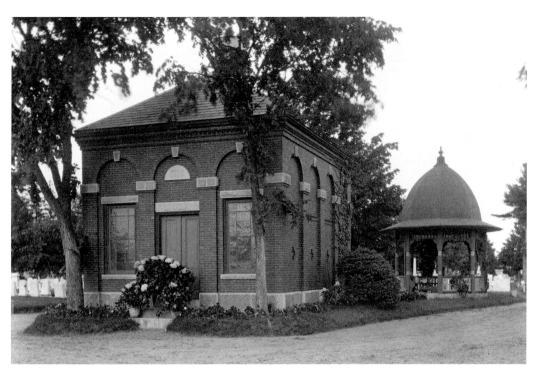

PINE HILL RECEIVING TOMB: In 1731, Pine Hill Cemetery covered one-and-a-half acres of land next to the meeting house. Today, over seventy-five acres are designated public burial grounds. Built in 1888, this brick building was used to receive caskets prior to burial.

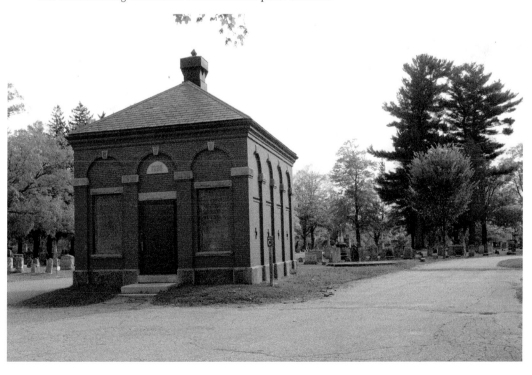

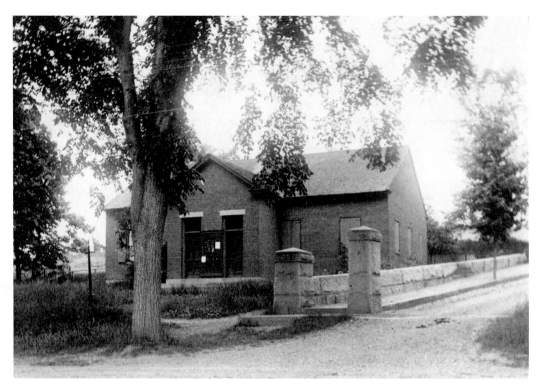

PINE HILL SCHOOL: Pine Hill School was built in 1824 at the entrance to Pine Hill Cemetery as a half primary and half secondary school. By 1904, only the fifth and sixth grades were taught. The school was abandoned in 1905 and torn down in 1913.

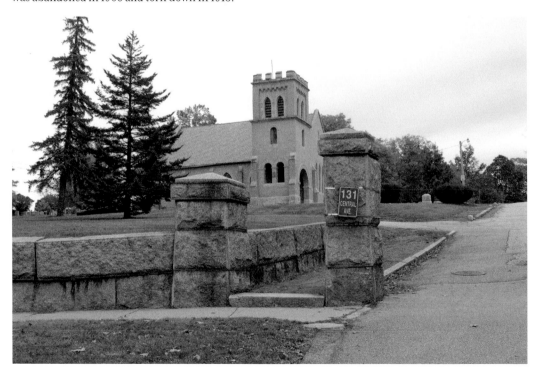

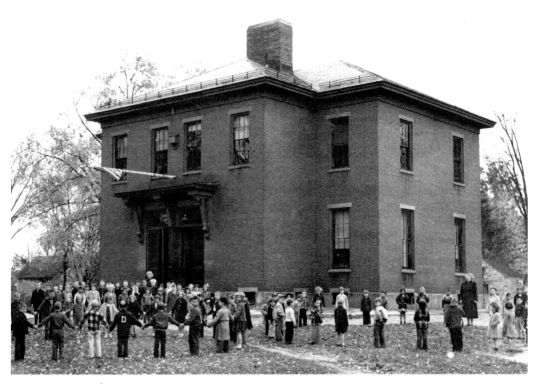

HALE SCHOOL: Originally known as the Locust Street Primary School and later the Hale School, it had four levels of primary education. Classes moved to Woodman Park School in 1953. The building is currently used as an office building.

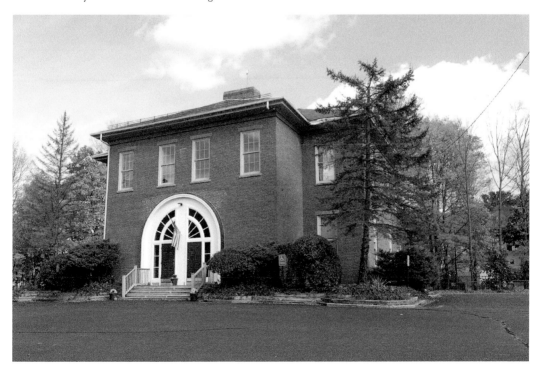

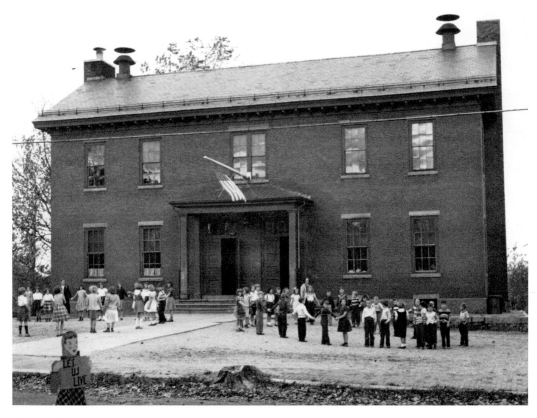

VARNEY SCHOOL: Known as the Washington Street Primary School when built in 1861, the name was changed in 1882 in honor of Judge John Varney, a school board member killed in the Baptist Church fire. The school closed in 1953 and became a law office in 1958.

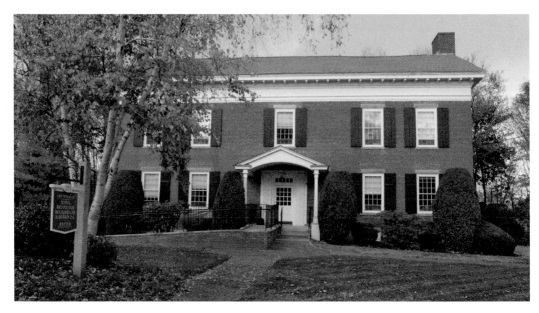

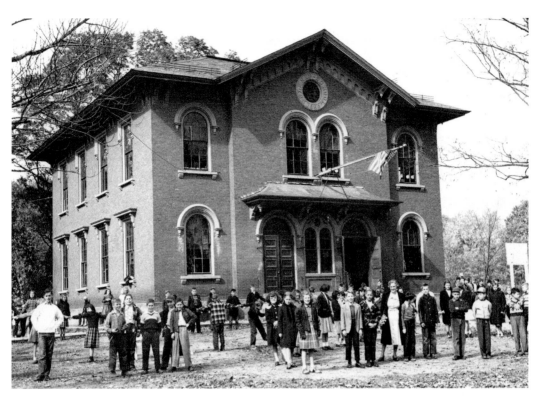

BELKAP SCHOOL: Built on the site of Rev. Jeremy Belknap's home in 1855, it was used as a grade school until 1953, when students moved to the new Woodman Park School. The building is currently the office of Dover Eye Care.

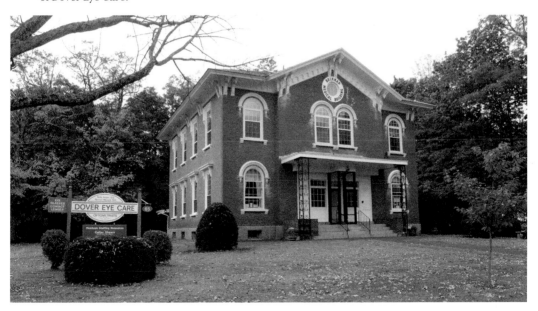

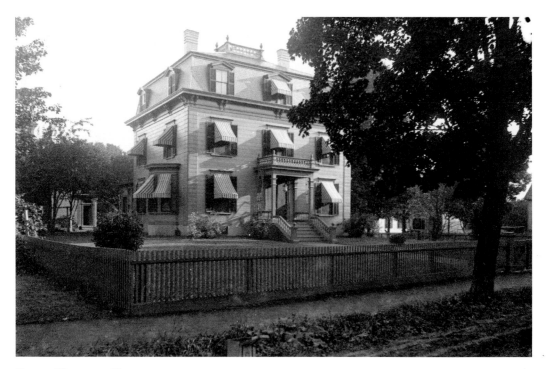

FRANK WILLIAMS HOME: Frank Williams, son of Isaac B. Williams, joined his father's leather belt business in 1871, and built this lovely home on the corner of Cushing and Silver Streets. The home remained in the family for many years. It currently serves as a bed & breakfast inn and tea parlor.

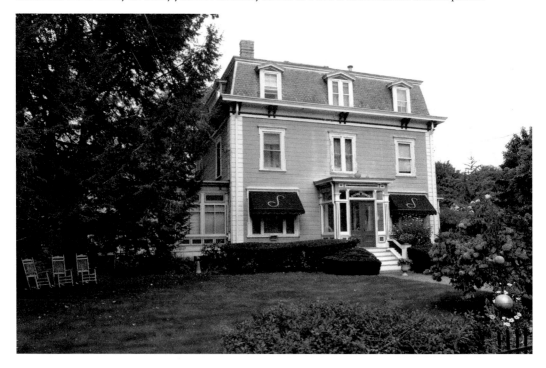

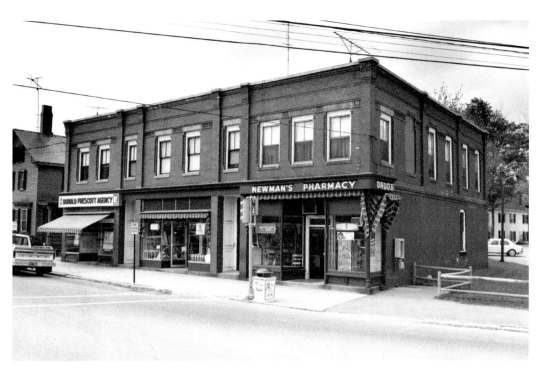

NEWMAN'S PHARMACY: Pharmacist Arthur Brown owned the Tuttle Square drug store until the 1950s, when Glen Robinson became owner-pharmacist. In 1992, the building was sold to the First Parish Congregational Church and today serves as a church thrift shop.

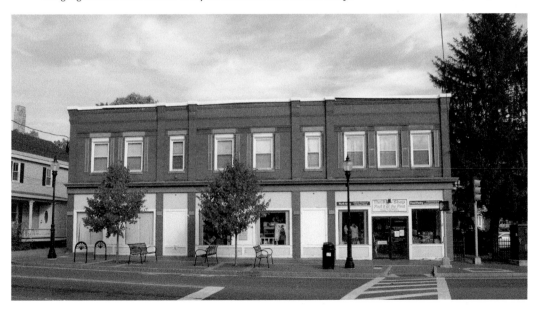

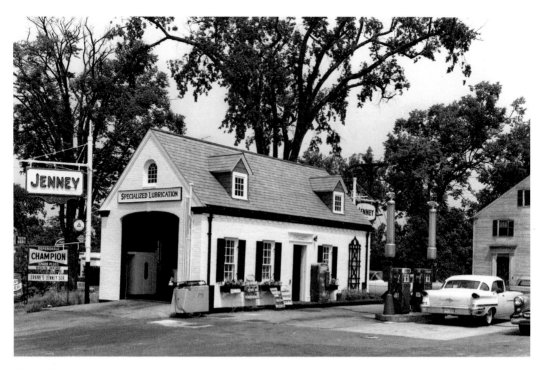

FRANK'S JENNY STATION: A popular service station at Tuttle Square in the 1950s-1960s era. The building was renovated as a Century 21 Real Estate office and is currently home to The Masiello Group.

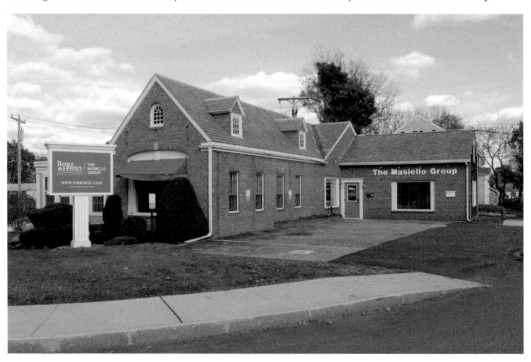

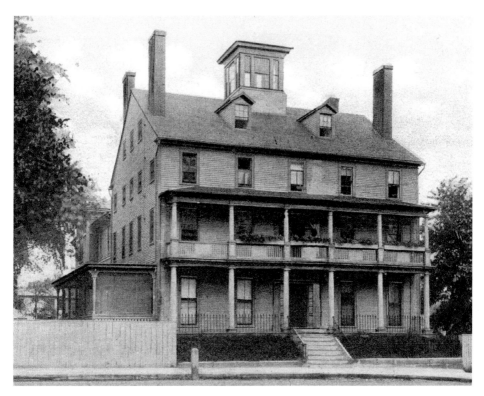

NEW HAMPSHIRE HOTEL: A popular hotel/inn, operated by Samuel Wyatt, was visited by a young politician named Abe Lincoln during his overnight visit to Dover in March of 1860. In 1880, it became the Sacred Heart Convent for the Sisters of Mercy. The building was removed in 1912 to build the Saint Mary School, now St Mary Academy.

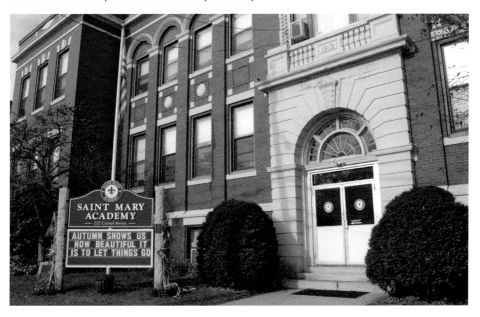

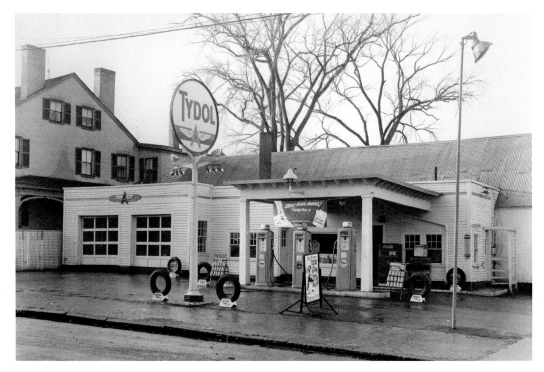

GREENAWAY TYDOL: Arthur Greenaway operated a Tydol filling station on Central Avenue at Kirkland Street in the 1940s-1950s. It became Sonny's Safeway in the 1960s-1970s. Today, Domino's Pizza delivers fresh pizza from this site.

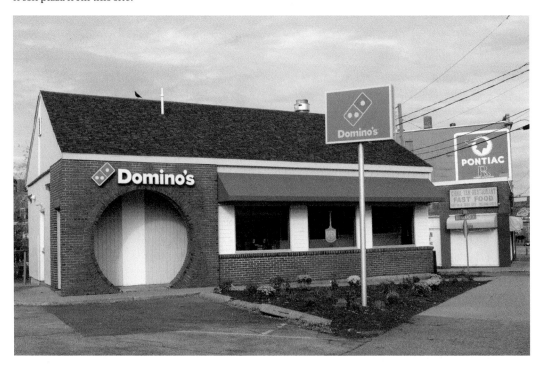

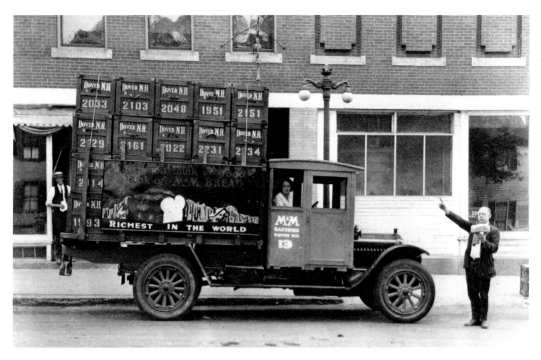

PYTHIAN CASTLE: Dedicated in 1914 by the Knights of Pythias Olive Branch No. 6, the building has been home to many street-level businesses over the years. M & M Bakery started here. It is currently home to the famous Moe's Italian Sandwich Shop and Glass Routes.

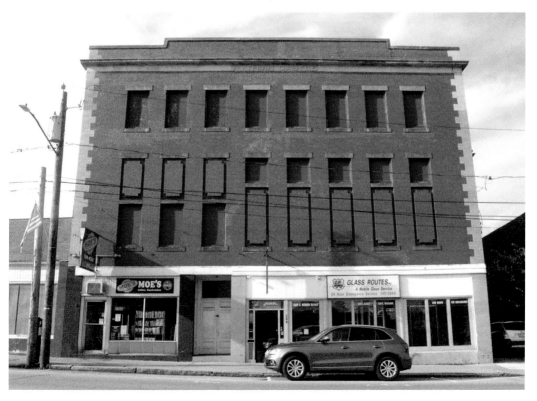

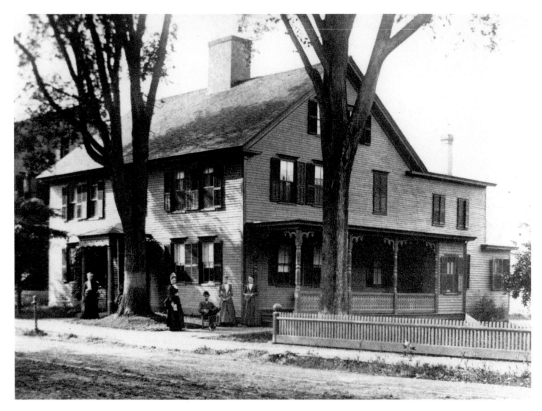

MELLON-PEIRCE-PIPER HOME: The house was built in the 1790s for attorney Henry Mellon. Dover's first mayor, Andrew Peirce, moved here in 1822. In 1880, G. Fisher Piper purchased the home. Today, the house is Seaton & Lohr Law firm at 53 Silver Street.

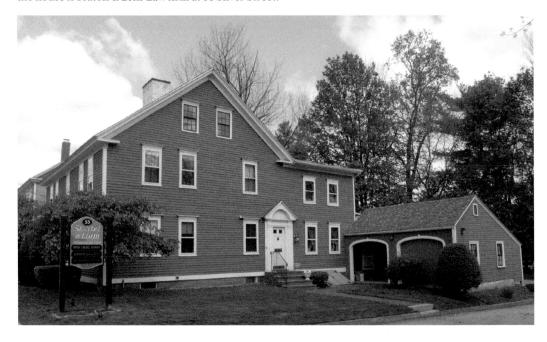

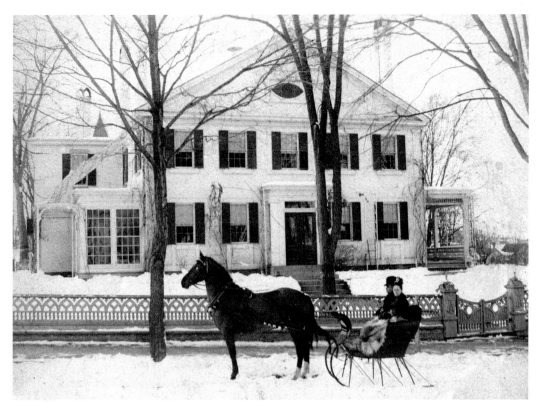

LINCOLN BUILDING: Built in 1831, it was the home for the Cocheco Mill superintendents until 1940 when the mills closed. For many years in the 1950s, it was medical offices for local doctors. Abe Lincoln stayed as a guest during his March campaign tour in 1860, hence the name. Today, it is the offices of Leone, McDonald and Roberts PA.

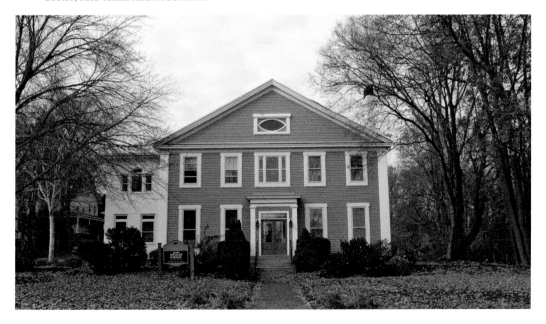

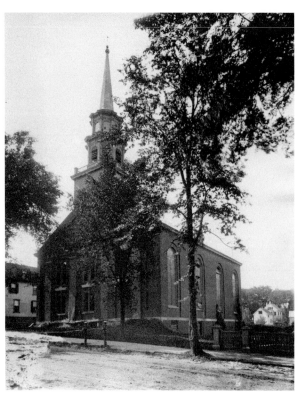

FIRST UNITARIAN CHURCH: After a split from the Congregational church, a brick house of worship was built on Locust Street in 1828. Senator John Parker Hale gave a farewell speech on the steps prior to his leaving to serve as ambassador to Spain. In 1939, the Greek Community acquired the building until it was destroyed by fire in the 1950s. The present Annunciation Greek Orthodox Church was built on the site

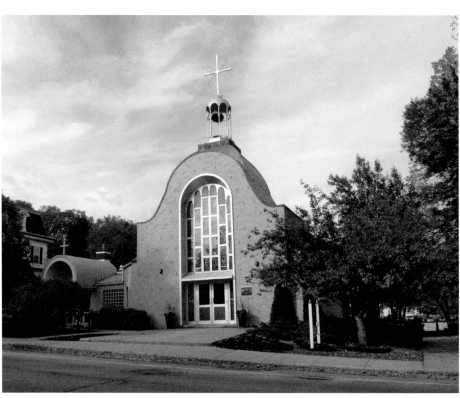

SOLDIERS & SAILORS MONUMENT:

On October 19, 1912, 150 Civil War veterans marched from the Third Street Boston & Maine Railroad station to the front lawn of the Dover Public Library, to officially unveil and dedicate the newly erected Soldiers and Sailors Monument—a gift to the city from Civil War veteran and prominent attorney, Col. Daniel Hall. On October 20, 2012, Woodman Museum trustee Thom Hindle and Mayor Dean Trefethen, with members of the 5th N.H., 12th N.H., and Kearsarge Afterguard, placed a wreath in celebration of 100 years and a tribute to the soldiers and sailors that served in our nation's bloodiest war.

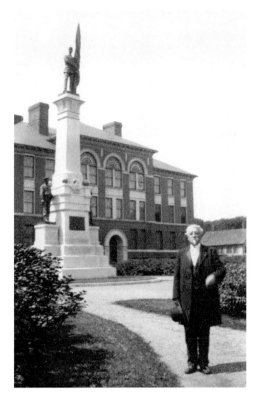

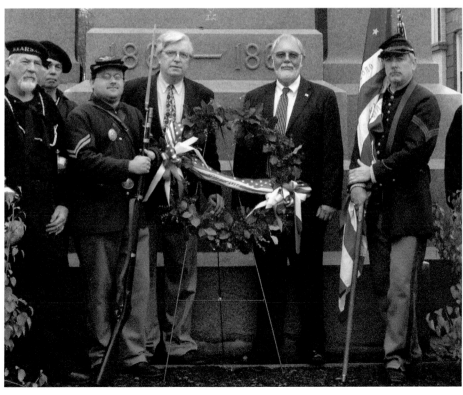

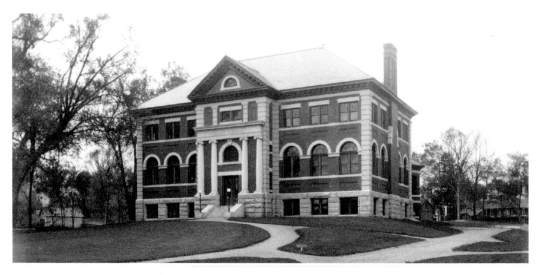

PUBLIC LIBRARY: The library was built on the site of the William Hale Jr. home when Andrew Carnegie gave $30,000 for the construction of a public library. Dedicated on July 19, 1905, the library saw the first expansion in 1988 with a 5,600-square-foot addition under the direction of librarian Don Mullen. The library continued to advance with new electronic technology under the direction of librarian Cathy Beaudoin, who served twenty-one years as director. She received the Library Director of the Year award and Citizen of the Year award in 2018. Cathy retired in March of 2020 after forty-four years of library service.

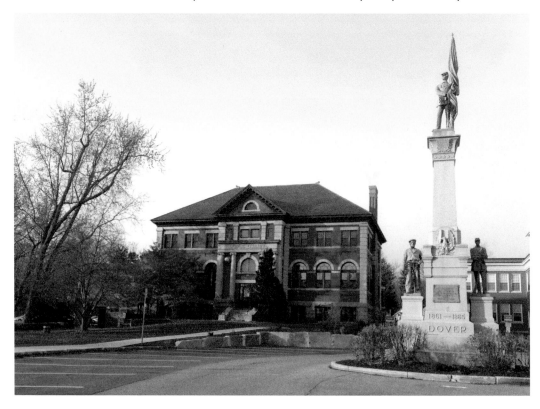

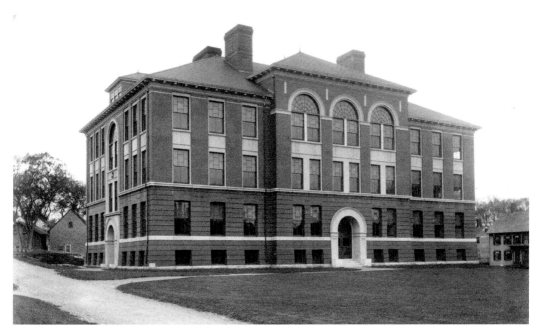

McCONNELL CENTER: In 1905, a new high school opened on Locust Street to meet the needs of a growing student population. In 1968, a larger high school was built on the Durham Road and this building became the junior high. A new middle school opened in 2000 and the building was renamed the McConnell Center after Korean War hero, Joseph McConnell. It now serves as a community center and veteran's park.

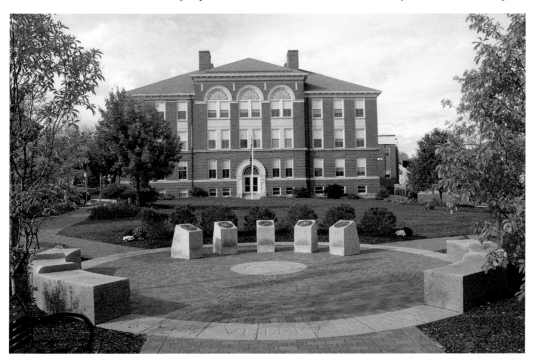

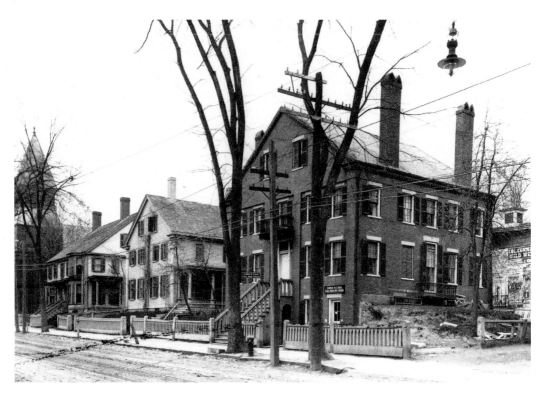

DR. LEVI HILL HOME: Dr. Hill moved to Dover in 1848. He served as President of the Dover Medical Society in 1854. The house was removed to build a new post office on Washington Street.

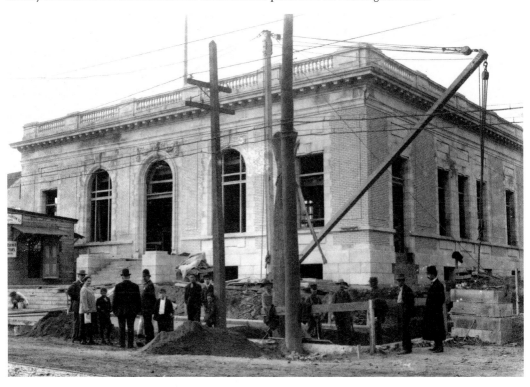

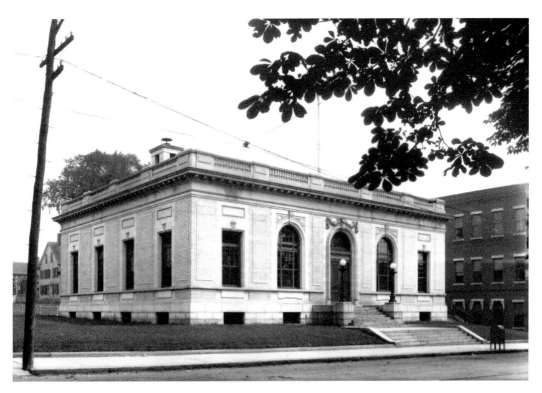

POST OFFICE: Construction was completed in 1909. Many additions and changes have been made since, with a new parking lot and the main entrance and lobby moved to the rear of the building in 1994.

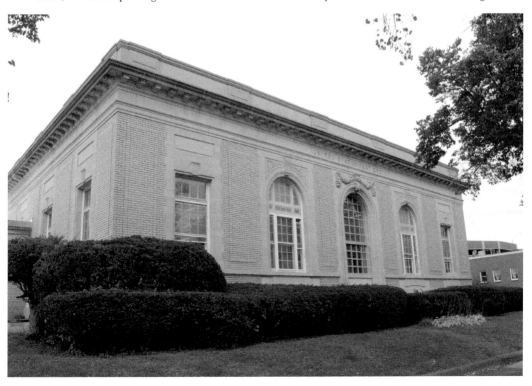

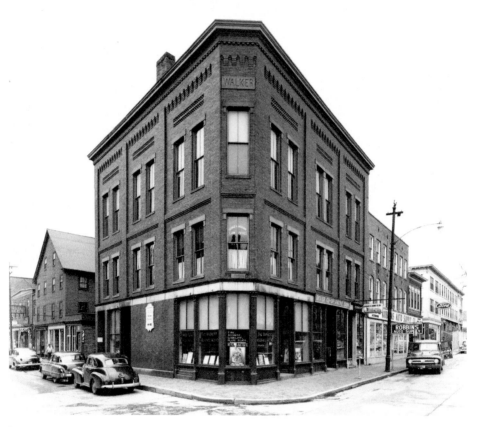

WALKER BLOCK: Dover Cooperative Bank, established in 1890, was located for many years on the corner of Washington and Locust Streets. After a fire damaged the third floor, the building went through a complete renovation and the bank eventually became Dover Federal Savings and Loan at this location until 1972.

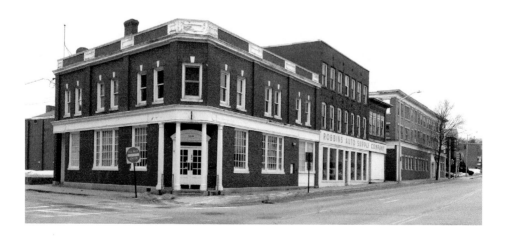

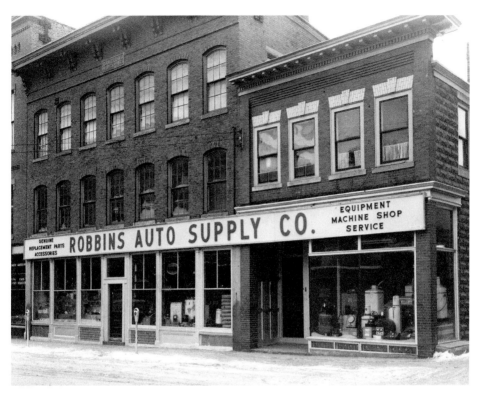

ROBBINS AUTO SUPPLY CO: Founded in 1933 by Sidney Robbins, this Washington Street automobile parts store grew into a twelve-location chain with over 300 employees. In 2009, the business was sold and in 2018, the entire block was demolished and replaced with a modern structure.

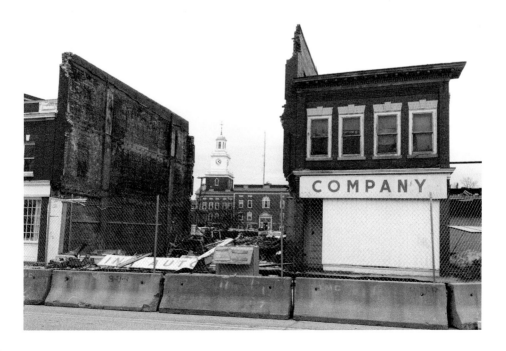

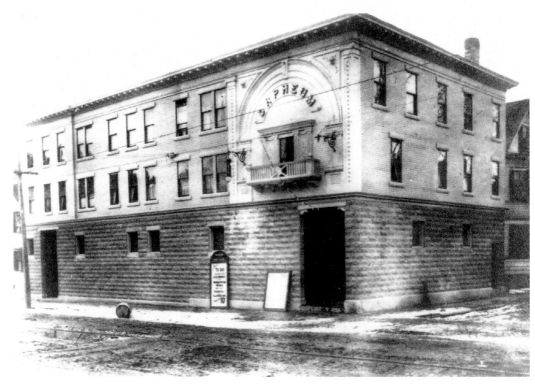

ORPHEUM THEATRE-HOTEL: The Orpheum Theatre opened in 1912 with a hotel on the upper floors. In 1935, it became the State Theatre until closing in 1955. Most recently it was used as office space for Robbins Auto Supply, and then demolished in 2018 to make room for the new Orpheum luxury apartment complex.

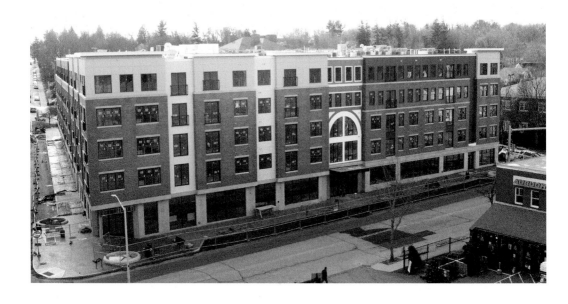

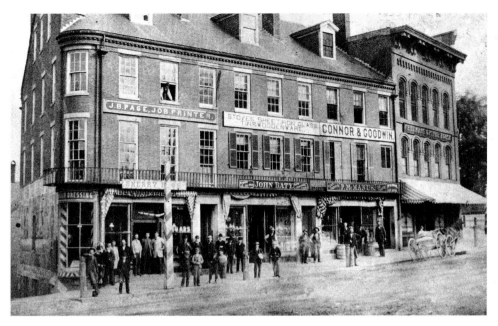

TETHERLEY'S/FOSTER'S BLOCK: It was located on the corner of Payne (now Henry Law) and Washington Streets at Central Square, and next door to the Exchange Block. In the 1890s, *Foster's Daily Democrat* newspaper moved here, and over time took over the entire block. In December 2014, the paper was sold to Seacoast Media Group. Today, the renovated Foster building is commercial space and luxury apartments.

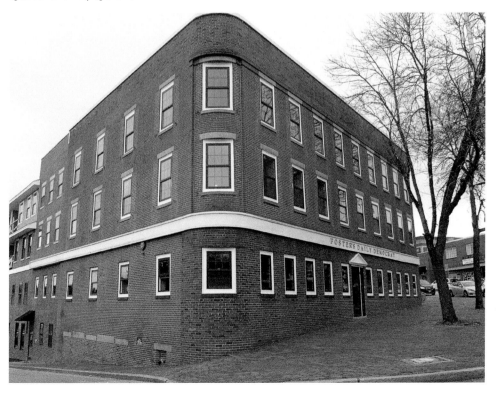

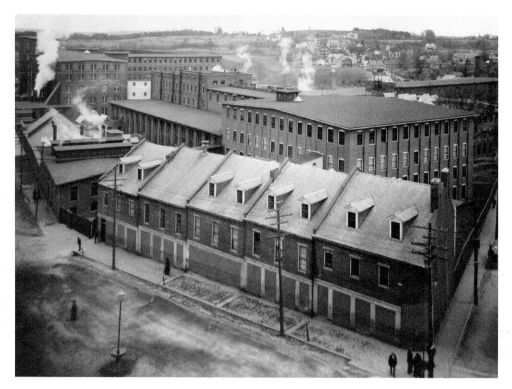

COCHECO PRINTWORKS: Fifteen buildings were constructed between 1842 and 1844 on land now referred to as Henry Law Park. By the 1880s, the Cocheco Printworks were renowned worldwide, producing 65,000 yards of printed cloth a year. In 1909, production was moved to the Pacific Mills headquarters in Lawrence, Massachusetts, and the buildings were torn down in 1913. Today, it is home to the lovely Rotary Garden and Amphitheater.

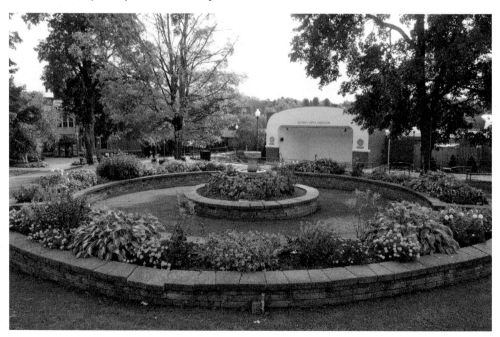

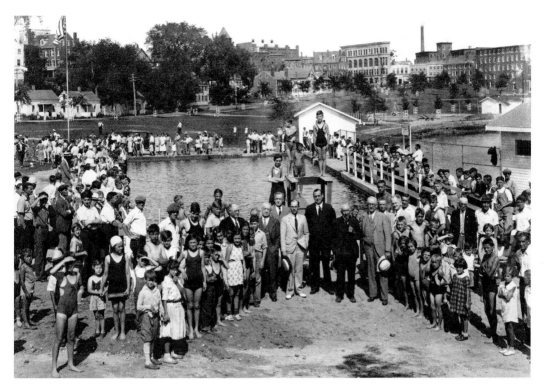

HENRY LAW PARK: In August 1937, Mr. Henry Law dedicated the gift of a new outdoor pool to the city of Dover. On June 24, 2017, Mayor Karen Weston, City Officials, Children's Museum, and members of the Paul Cox family cut the ribbon for the new Adventure Playground dedicated in memory of Martha Cox, a promoter of health and well-being for children.

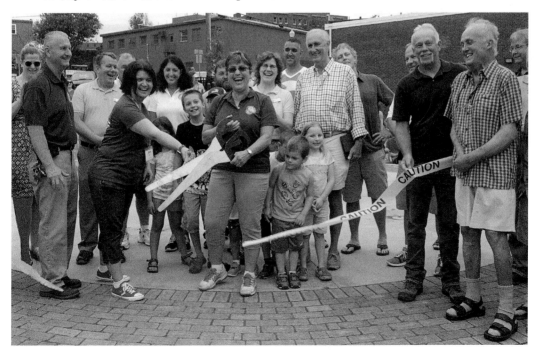

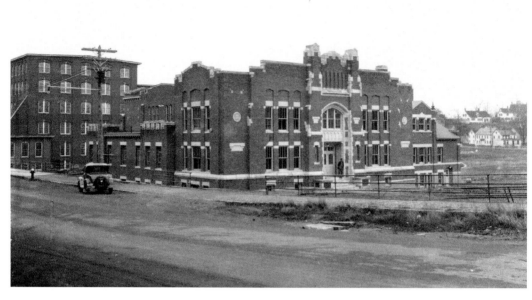

CHILDREN'S MUSEUM: An Armory building was built in 1930 on the site of the old print works for Battery B 197th Regiment, Coast Artillery of the New Hampshire National Guard. In 1962, the building became a recreational facility for the city and named the Butterfield Gym. In 2008, the building was again renovated to become home for the Children's Museum of New Hampshire.

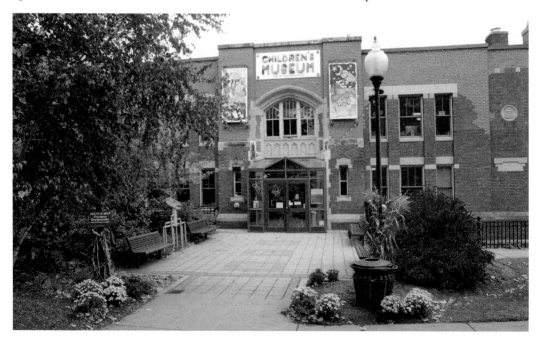

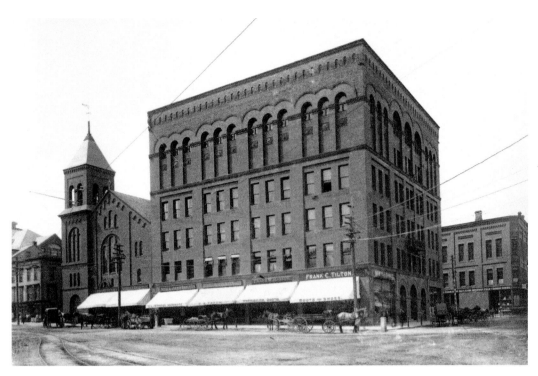

MASONIC TEMPLE: The temple was built on the site of two former city hall buildings in 1890 at Central Square. A fire on March 29, 1906, destroyed the building and many established businesses. At a cost of $75,000, a new building was rebuilt in 1907. In 1990, the Masons moved, and the building went through major renovations. It currently houses legal and professional offices and local businesses at street level.

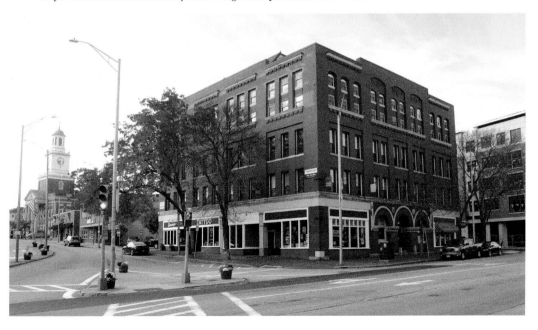

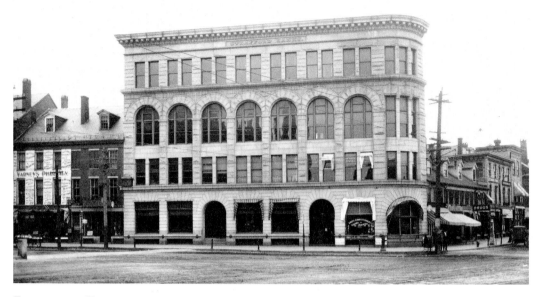

FORTRESS OF FINANCE: Designed by local architect, A. T. Ramsdell, this notable structure was constructed in 1895 using Milford pink granite and stands four stories high. It was originally built for and remained the Strafford Banks until 1963, when the bank moved across the street. The well-known businessman's Bellamy Club occupied the top floor. The building today has many legal and professional offices and a commercial restaurant on the ground floor.

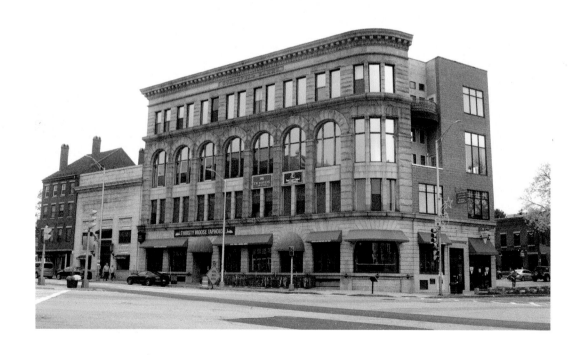

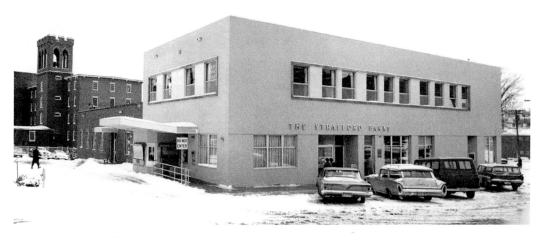

STRAFFORD – TD BANKS: In 1963, a new modern bank opened with parking across the street from the 1895 location. In 1978, the Strafford Banks celebrated the bank's 175th anniversary. In 1984, the bank became Southeast Bank for Savings and moved into a new brick building on Washington Street. After several renovations and banks occupying the Central Avenue building, the 2018 view shows the current occupant, TD Bank, just before another major renovation to the building.

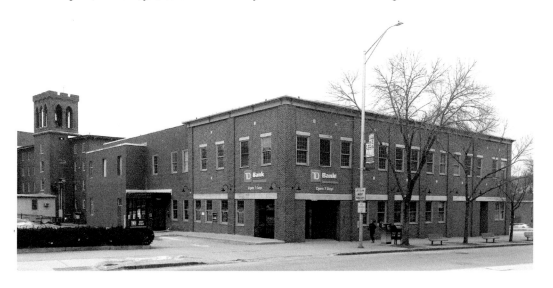

STRAFFORD NATIONAL BANK

DOVER, NEW HAMPSHIRE

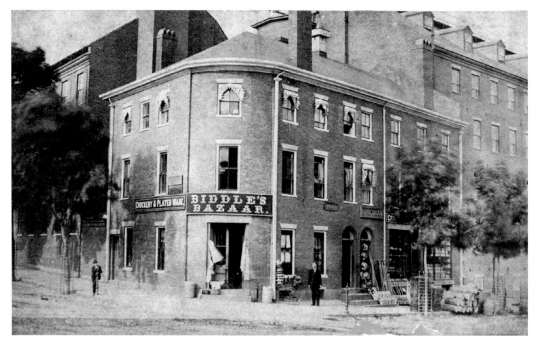

BIDDLE'S BAZAAR: In the 1890s, a glassware and crockery store operated at the corner of Central and Washington Streets at Central Square in part of the mill office complex. In later years, the office of prominent attorney, Dwight Hall, occupied the second floor. The building was removed in the 1930s and the new building is currently the office of Shaheen and Gordon Law firm.

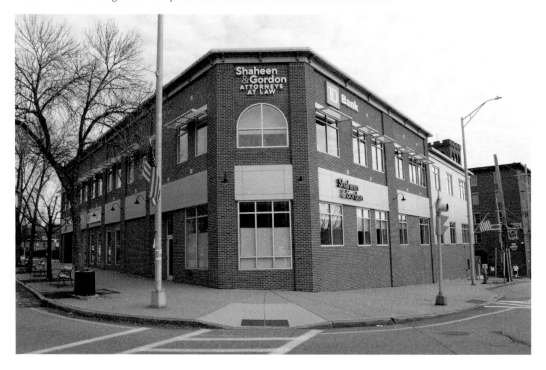

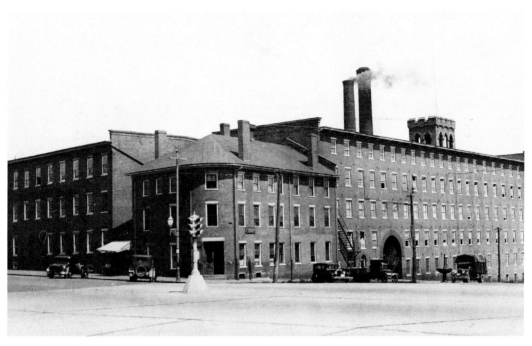

COCHECO MANUFACTURING: Founded as the Dover Cotton Factory in 1812, it was enlarged in 1823 as Dover Manufacturing and again by Cocheco in 1827. By 1898, the mill complex covered over 30 acres of floor space, operating 130,000 spindles in 2,800 looms. Over 2,000 workers were paid an average wage of 53 cents a day. The newly renovated corner building today is home to TD Bank and Shaheen and Gordon Law Firm.

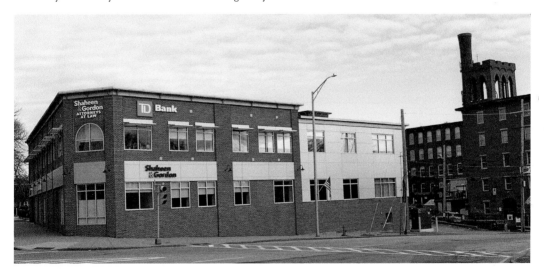

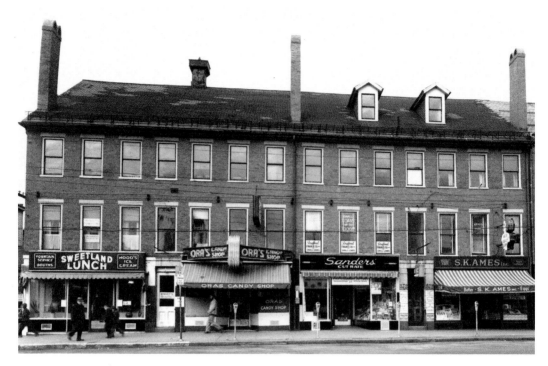

MERCHANTS ROW: Since the early mill days, this block would see various merchants offering goods and services to the mill workers. In 1943, the Vatistas family opened their landmark Sweetland Lunch on the corner of Orchard Street. Next door was the popular Ora's Candy that would become the Spartan Lounge. Today you can see customers at Best of Times barber shop waiting for a haircut.

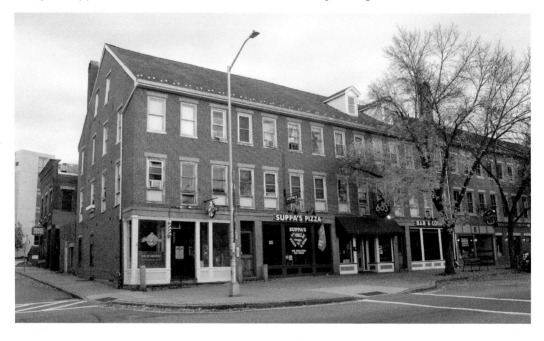

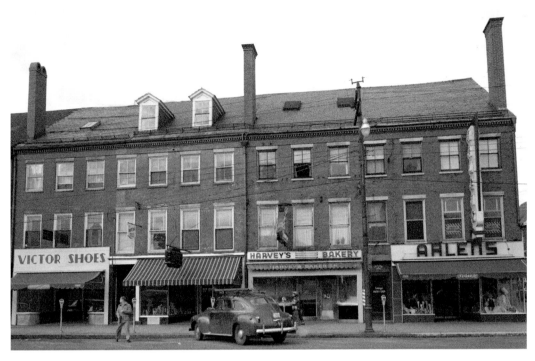

MERCHANTS ROW: Arlen's women and children's clothing store operated here in the 1950s, and the Max Cohen family opened Helene's clothing in the 1960s. Christine's gift shop, owned by Bill and Barbara Caron, operated until 1988 when Nicole's Hallmark opened and closed in October 2019.

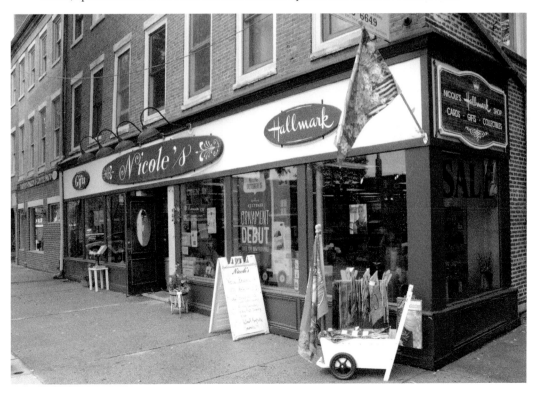

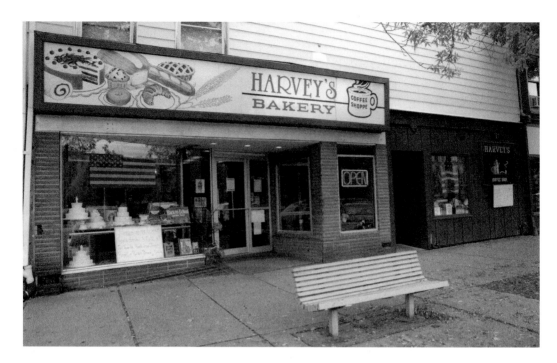

Harvey's Bakery:

The bakery was stablished in 1932 by Harvey Bernier in Rochester. With the help of the young baker, Ray Guillmette, a shop was opened in Dover during the late 1940s. Ray eventually took over the shop and brought his family into the business. In 2007, the family celebrated seventy-five years in business with a ribbon cutting unveiling a newly renovated shop. Ray was recognized in 2004, and daughter, Pam Simpson, in 2012, as Dover Citizens of the Year. Today, daughters Pam, Susan, and Karen continue to greet customers in the bakery and coffee shop.

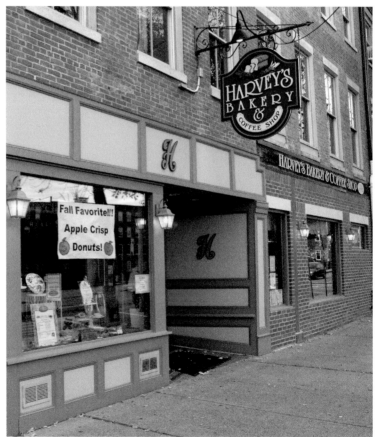

URBAN RENEWAL: The O'Neil House was one of two old mill houses saved during the $9 million urban renewal project that included Green, Orchard, Waldron, and Fayette Street neighborhoods. It also included the removal of the old I. B. Williams factory in the 1970s. Today the home has a coffee shop on Waldron Court with outdoor seating looking over the river.

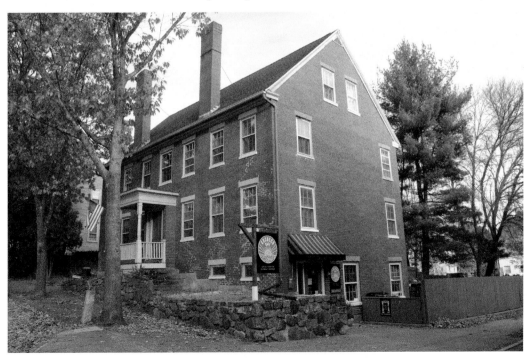

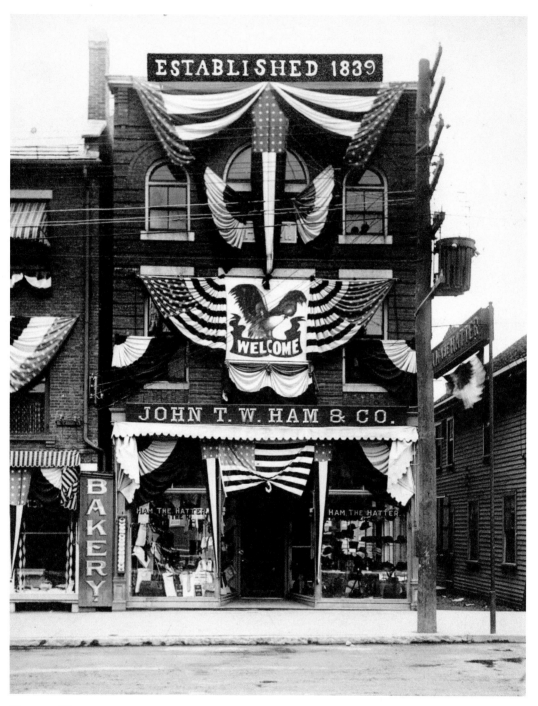

HAM THE HATTER: Founded by Amos Purington in 1839, it was re-established in 1859 under the name of Purington & Ham. Famously known in 1877 as "Ham the Hatter" when John Ham took over as a dealer in hats, caps, furs, and fraternal garb. In 1890, the business was again renamed John T. W. Ham & Co.

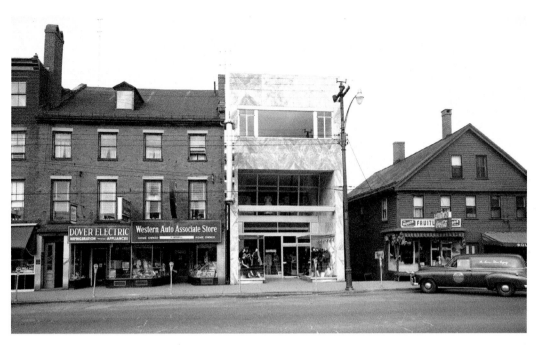

WESTERN AUTO-HOOZ APPAREL: In the 1950s, Western Auto was the place to buy everything from original Matchbox toy cars to boats. Next door, Ida Hooz sold the latest women's fashion with a full-service bridal salon on the second floor. Today, you will find a dental office and a real estate broker in the newly renovated building.

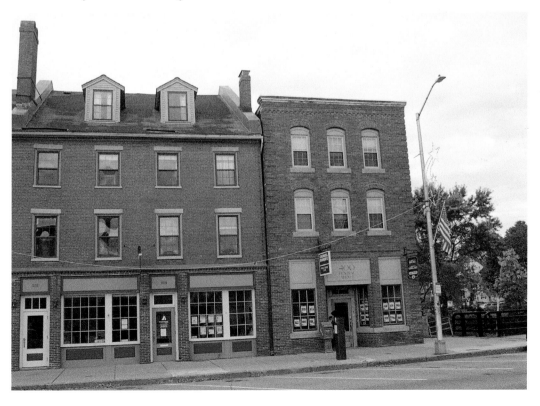

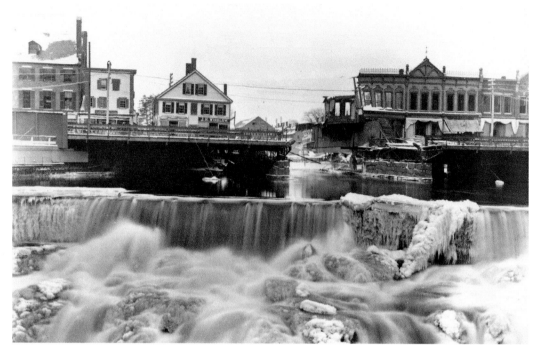

CALAMITY ON THE COCHECHO: Sunday, March 1, 1896, is known as Dover's Black Day. In just twelve hours, the city lost three bridges, a portion of the Bracewell Block, Cocheco Mills flooded, and a major fire destroyed the Converse & Hammond Lumber located on the landing. It would also be the end of schooner shipping in Dover, as the storm put back all the sand, silt, and debris that had been previously dredged.

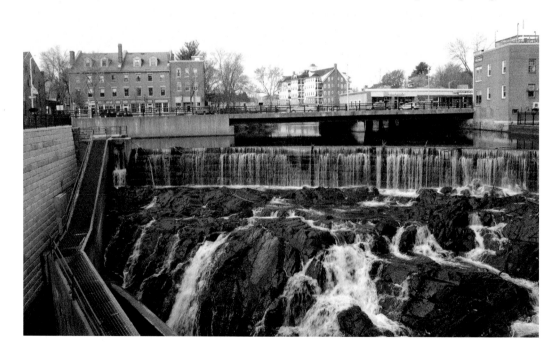

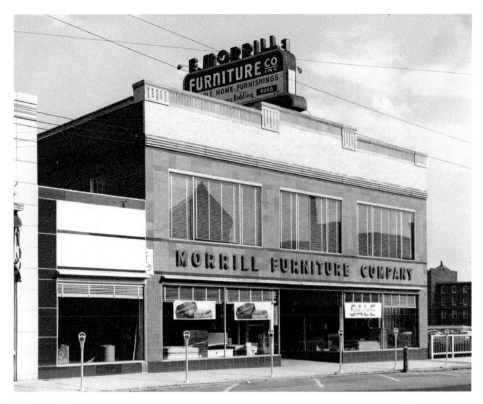

MORRILL FURNITURE: It was established in 1843 on Washington Street by E. Morrill as a crockery, drapery, and furniture store. In 1957, Thomas Monahan acquired the business and operated on the Central Avenue Bridge, until the renovations for the mill plaza in the 1980s.

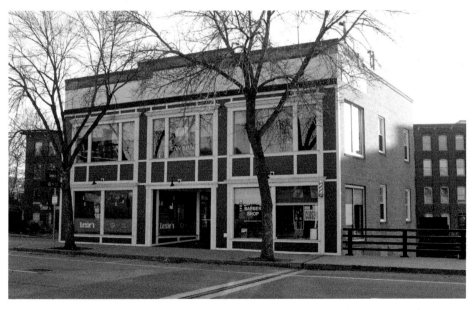

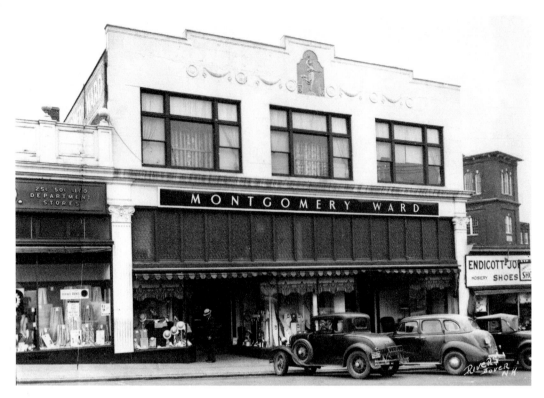

MONTGOMERY WARD: One of Dover's early chain department stores was located next to W. T. Grant. Montgomery Ward moved to the Newington Mall in the 1970s and the building was renovated into several shops: Franklin Galleria and Just the Thing Antique Shop.

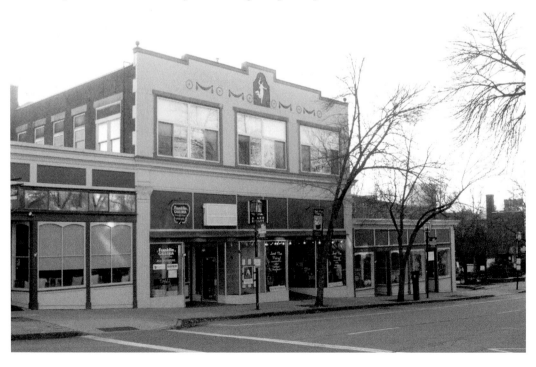

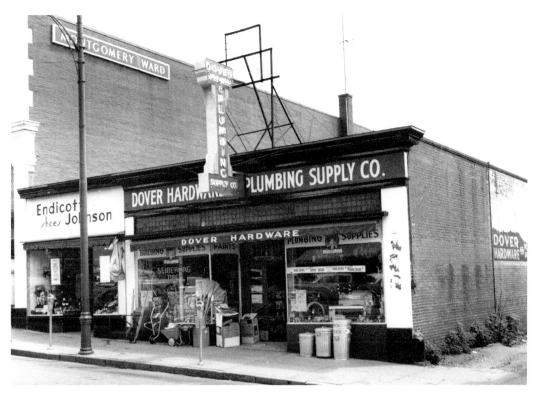

DOVER HARDWARE & PLUMBING SUPPLY: The Stocklin family opened their full-service hardware store in the heart of downtown during the 1930s. They continued to operate at this location until the mill renovations in the 1980s, when the building was divided into small retail and office space next to a new courtyard.

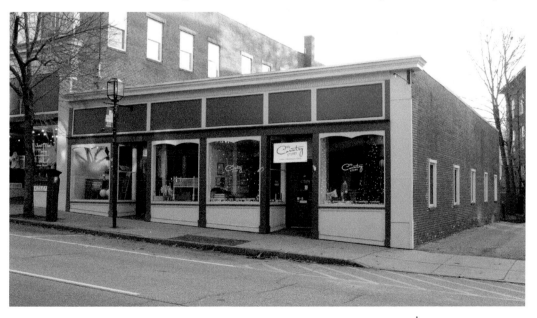

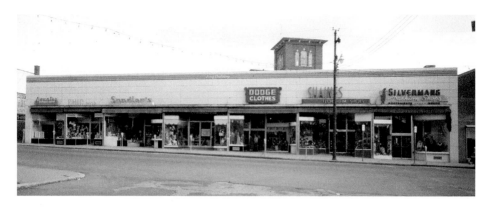

DODGE CLOTHES-SHAINES-SILVERMANS: This 1950s color chrome shows the downtown Central Avenue block of "mom and pop" locally owned stores.

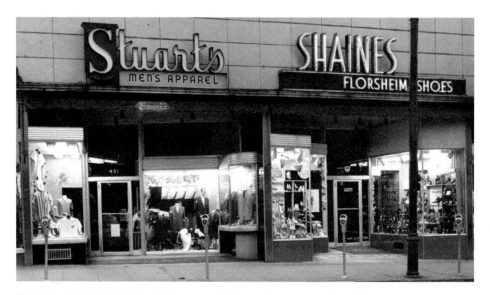

COCHECO MILL RENOVATION: The early 1980s saw the partnership of Tim Pearson and Joseph Sawtelle renovate and rehab the old block of stores.

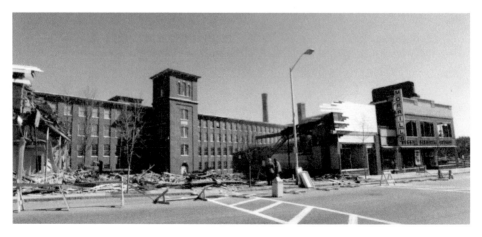

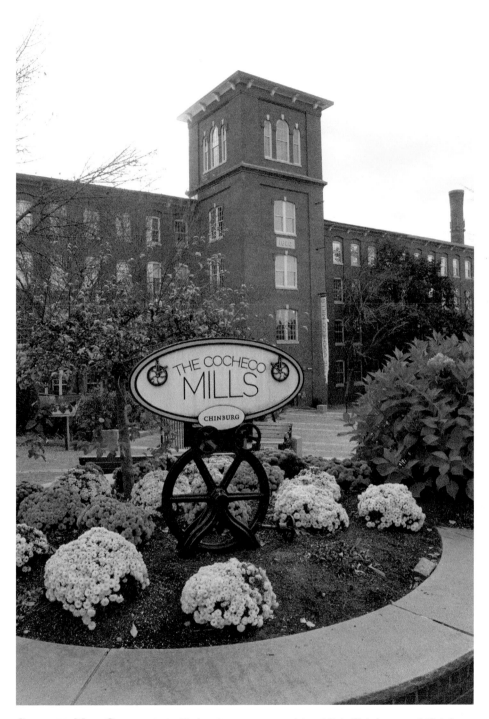

Cocheco Mill Courtyard: Under the new ownership of Eric Chinburg and Chinburg Properties, the mill complex has been completely renovated into a commercial and residential facility. A lovely brick courtyard leads to the main entrance, showcasing the mill building and allowing space for small community events and outdoor art exhibits.

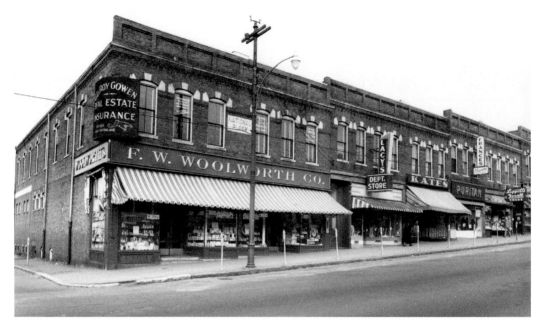

F. W. WOOLWORTH: The National Block was erected in the early 1880s and featured Dover Clothing Co. In the 1950s, Max Lacy operated a ladies clothing store with Gowen Insurance/Real Estate on the second floor. In recent years, the Lucky Garden Chinese Restaurant serves on the corner.

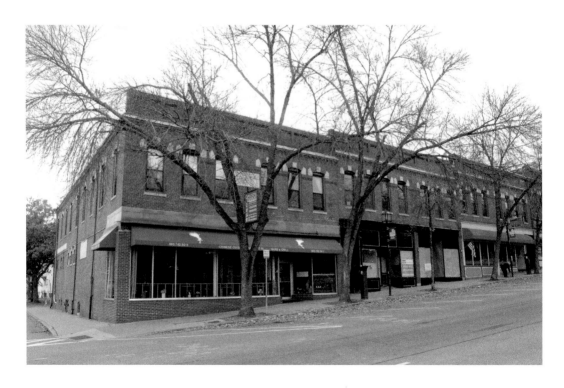

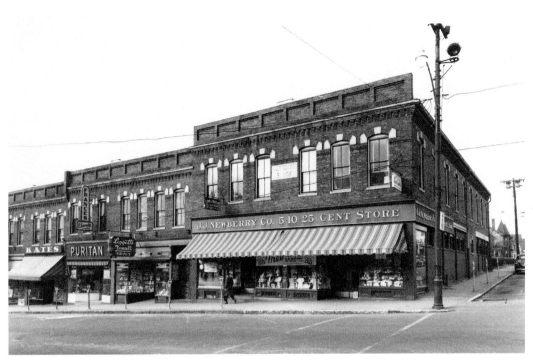

J. J. NEWBERRY: Dearborn Dry Goods and Charles Hodgon's Jewelry could be found here in the late 1800s-early 1900s. J. J. Newberry Five & Dime was on the corner in the 1950s, becoming Gallery of Gifts in the 1970s, with the Catalfo Law Firm occupying the second floor. Today, Market Square Jewelers specializes in vintage and estate jewelry.

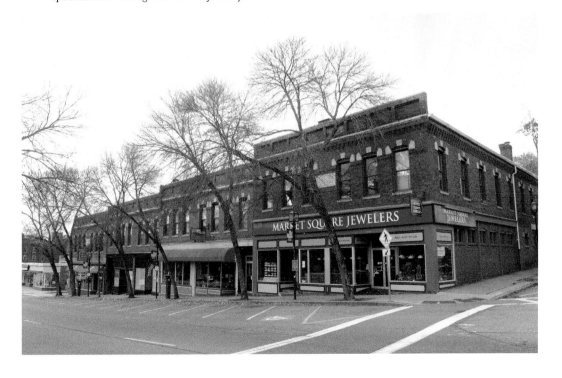

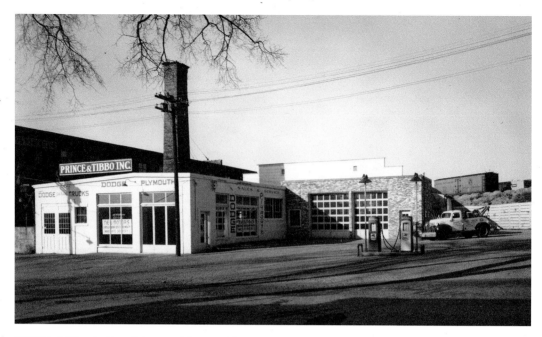

PRINCE & TIBBO: Aime Prince and Bruce Tibbo operated a Dodge-Plymouth sales and service garage at 45 Chestnut Street in the 1940s-1950s next to the old cotton warehouse. The old warehouse was torn down during urban renewal and today the renovated garage serves the Dover Loyal Order of Moose 443.

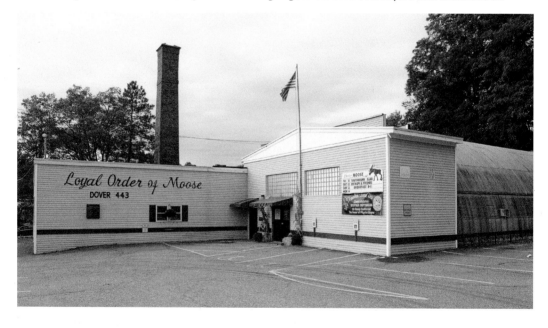

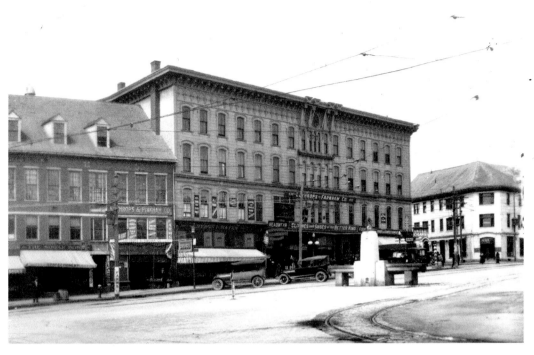

FRANKLIN SQUARE: The original Morrill Block to the left, was built by Joseph Morrill on land purchased from Cocheco Manufacturing Co. in 1844. Dr. James Lothrop operated Lothrop & Pinkham Drug Store and Daniel Lothrop and Charles Farnham operated the popular Lothrop and Farnham shoe and clothing store next door in the larger section.

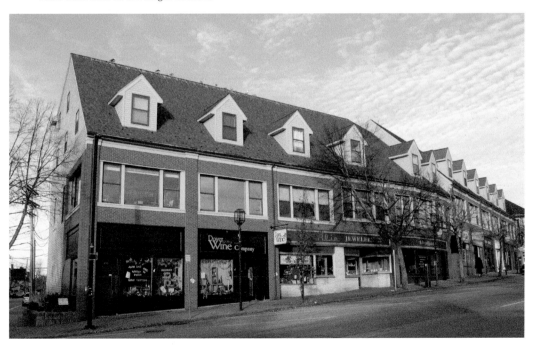

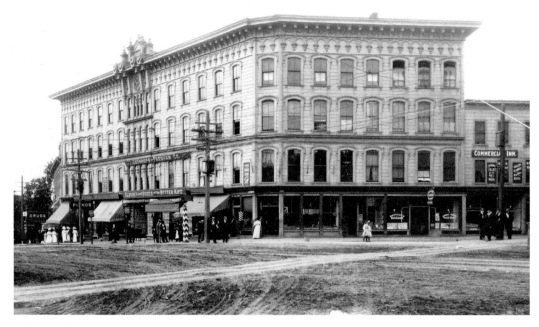

MORRILL BLOCK: Between 1870 and 1874, Morrill erected this massive four-story wooden structure on the corner of Third Street. Lothrop Farnham & Co. was a clothiers and hatters store in this block until the January 1932 fire destroyed the building—an estimated $1,000,000 loss.

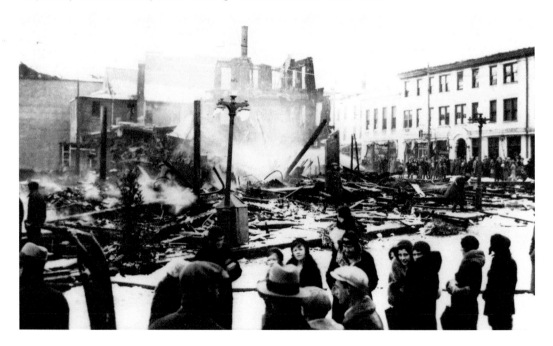

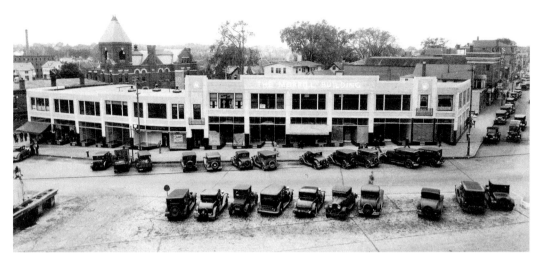

NEW MORRILL BLOCK: A new two-story Morrill Block was constructed offering retail spaces on the ground floor and office spaces on the second. In the 1990s, the building saw another major renovation, adding a third story with dormer windows for residential apartments.

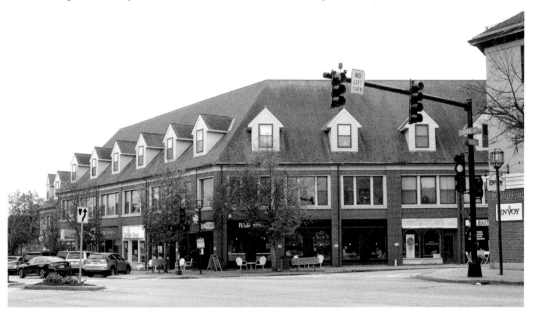

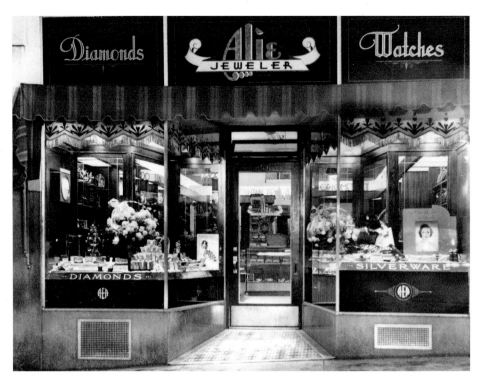

ALIE JEWLERY: Albert E. Alie was one of the first to move into the new Morrill Building in 1932, and in 2014 his grandson, third-generation, Leo Jr., celebrated 100 years in business, originally established in 1914 next to the American House Hotel.

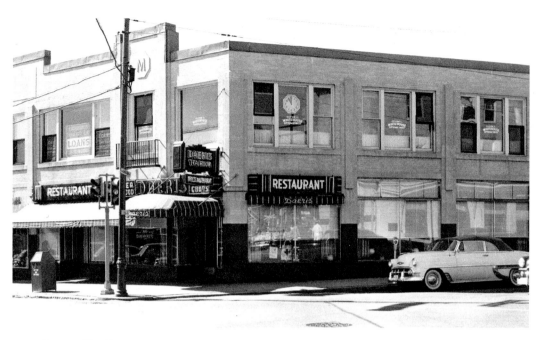

DAERIS TEA ROOMS: The Daeris family also opened in the new Morrill Block on the corner of Third and Central in 1932, offering Dover's finest soda fountain and candy counter. It was a popular spot for prom night dinners or an ice cream soda. In 1959, the restaurant was destroyed by fire. The corner space today is occupied by Flight Coffee Co.

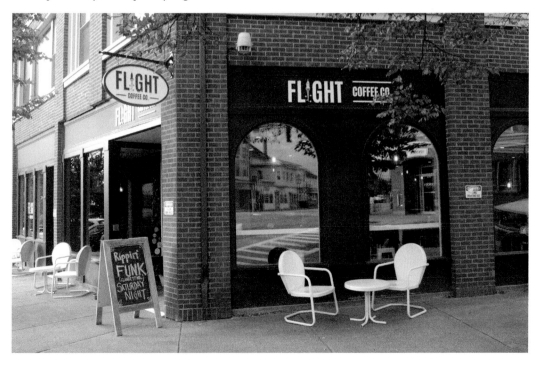

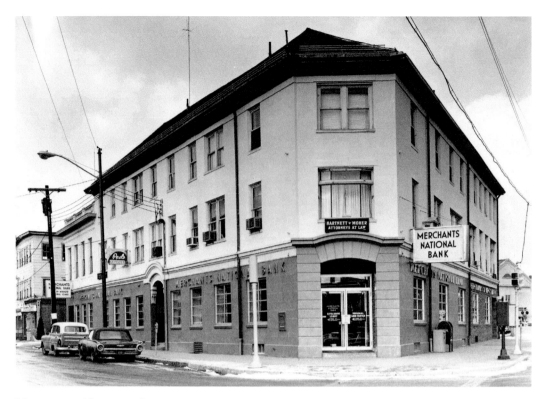

MERCHANTS NATIONAL BANK: Founded on April 2, 1900. In 1910, buildings on the corner of Third and Central were acquired and combined into one. Roy Ireland was president during the banks 50th anniversary and Fred Easter, in 1969, saw the interior remodeled and a north side branch open. On June 28, 1996, Merchants was taken over by Bank of New Hampshire and moved to the Strafford Bank building.

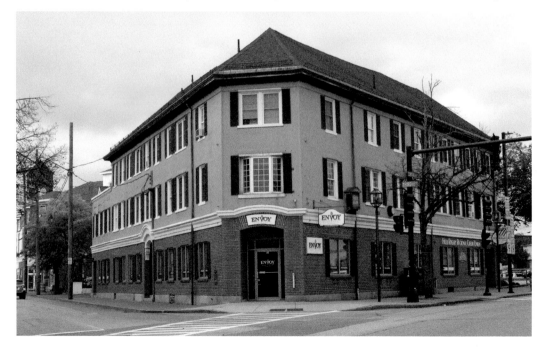

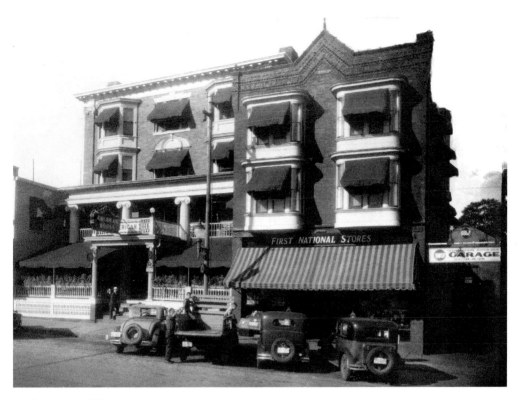

AMERICAN HOUSE: It was built in 1853 and advertised as "Dover's Finest Hotel" in the heart of Franklin Square. Presidents Teddy Roosevelt and Howard Taft each spoke from this spot during their visits in 1902 and 1912. The local Lions and Rotary Clubs held their weekly meetings in the dining room. Removed in 1964, the Days Inn now offers overnight accommodations.

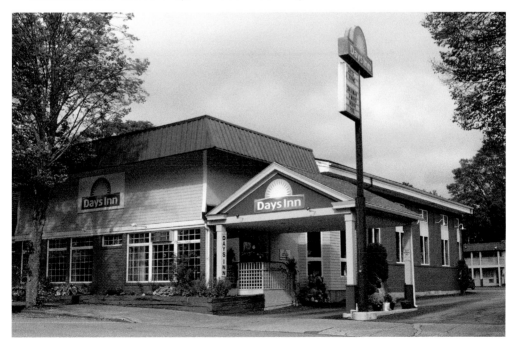

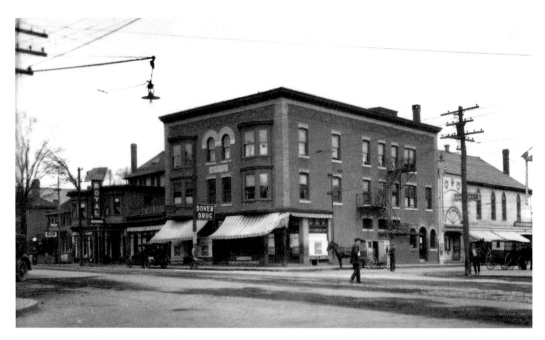

DOVER DRUG: Harry Davis, a druggist, operated on the corner of Broadway until Dover Drug was founded in 1920, offering a lunch counter. In 1989, a major facelift was seen on the exterior, and in 1991 the famous Dover Drug sign on the roof was replace with a Brooks Pharmacy sign. Baldface Books was located here for a few years and today you will find Dover's Federal Cigar offering the finest smoking cigars and a cigar bar.

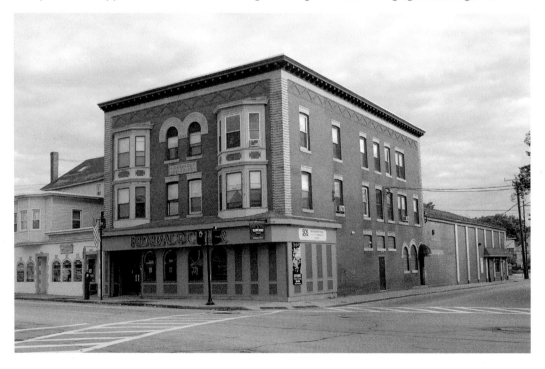

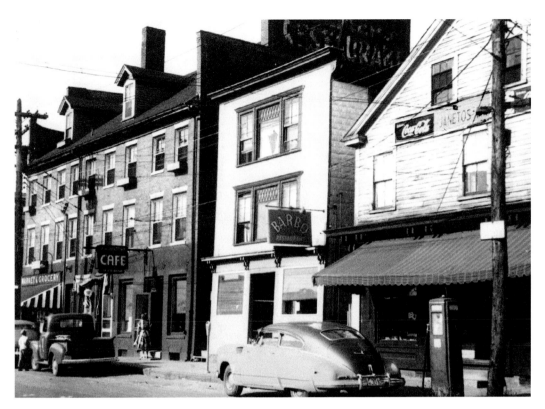

JANETOS SUPERETTE: Evangelos Janetos came to Dover in 1922 and married Ellen Wentworth and opened a store in 1924. Mary Janetos Bandouveres (Evangelos's daughter), her husband, George, and their children all celebrated the store's seventy-fifth anniversary in 1999. In 2014, their children celebrated ninety years. Daughter Karen Bandouveres Weston was elected mayor of Dover, serving three terms, and in 2019, the ninety-five-year-old business was awarded Grocer of the year.

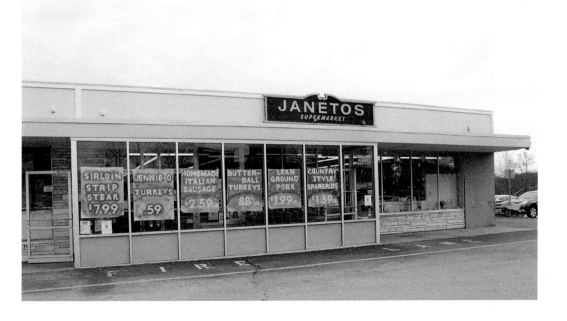

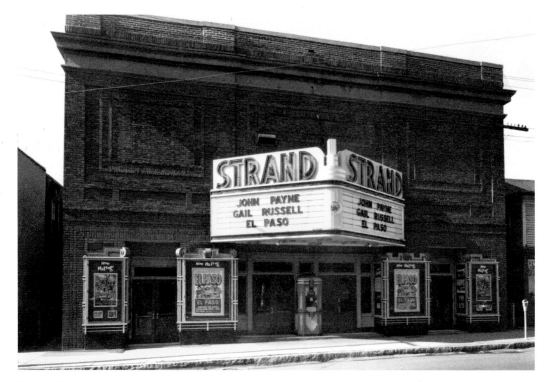

STRAND THEATRE: The Strand opened in 1919 with the silent film *Daddy Long Legs*, featuring Mary Pickford. On February 4, 1928, the first "talkie" shown in the state was projected on new sound equipment. *Mighty Joe Young* made an appearance in 1949 on a flatbed truck and *The McConnell Story*, with Alan Ladd and June Allison, held the East Coast premiere at the Strand during Dover's 1955 Centennial Celebration. After spending over $200,000 on renovations, Mike Spinelli hosted a grand re-opening gala on September 27, 1987.

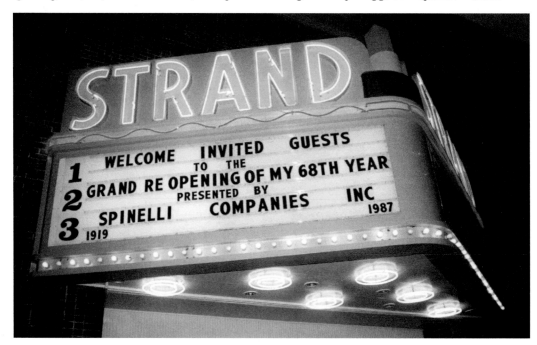

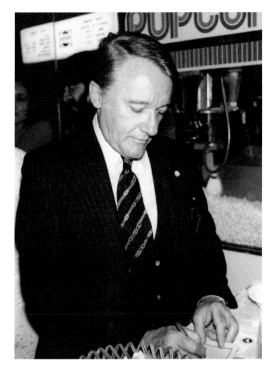

STRAND — STRAND

GRAND
SEPTEMBER 22, 1919

RE-OPENING
SEPTEMBER 22, 1987

SPINELLI COMPANIES

ONE HUNDRED YEARS: Hollywood star Robert Vaughn signs a souvenir program during the gala event. Sadly, in September 2009, the theater closed. In September 2015, the Strand re-opened again and on September 22, 2019, Dan Demers, the current owner, and Mayor Karen Weston, celebrated the theatre's 100th anniversary with a ribbon cutting and an evening showing of *Daddy Long Legs*, the theater's first movie.

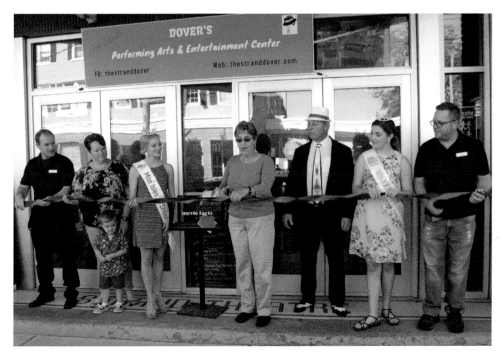

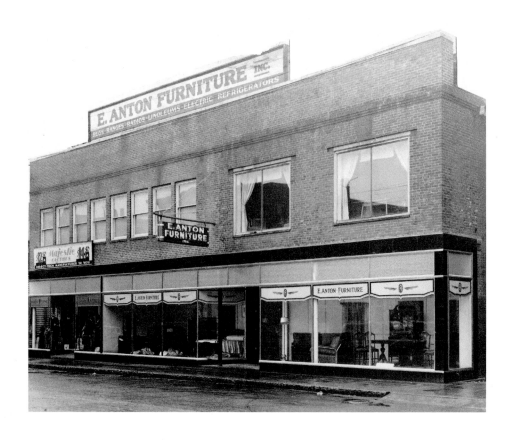

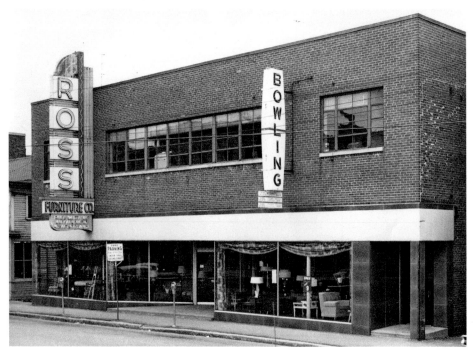

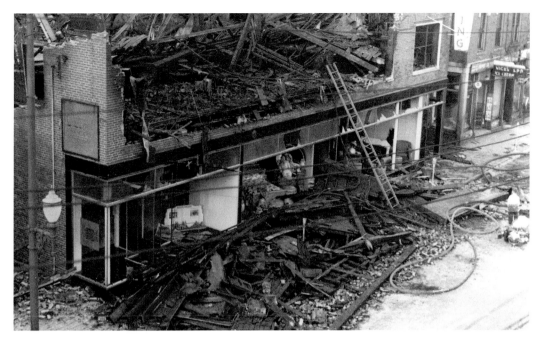

ANTON FURNITURE: Elias and Rosaline Anton opened their Third Street furniture store in the 1930s. In 1942, Ross Payeur bought and renamed the store Ross Furniture. On September 12, 1946, fire destroyed the building. Payeur rebuilt and continued operation until Bill Kafkas' purchase in 1978. Kafkas kept the store until his retirement and sold to employee Jason Howard in 1997.

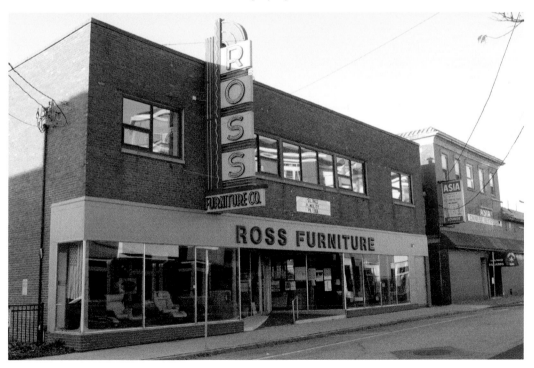

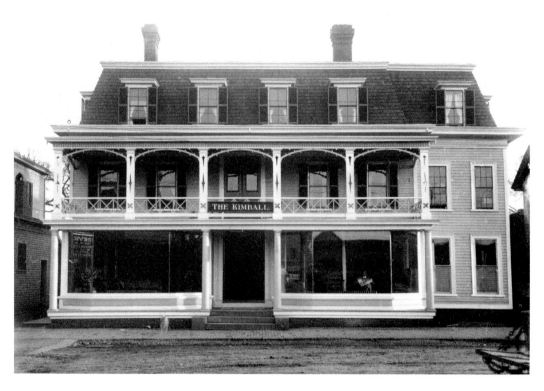

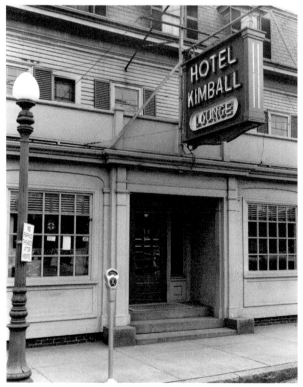

THE KIMBALL: A first class hotel opened across from the railroad station in 1871 called The Kimball, offering overnight lodging to people arriving by train. Around 1912, the hotel offered hot water and telephones in every room, unusual for the time. Recognized as Hotel Kimball and Lounge in the 1950s, they even had a barber shop.

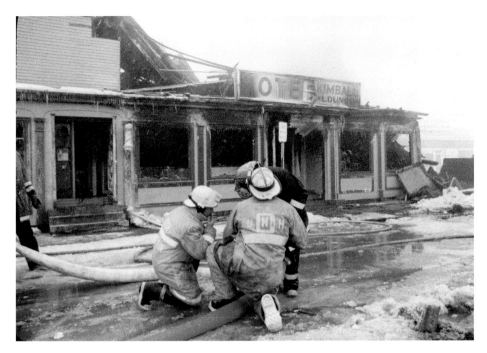

ASIA CHINESE RESTAURANT: The hotel served the community for over 100 years until it succumbed to a fire in 1982 that destroyed the entire landmark. Built on the site by the Wong Family, is the Asia Chinese Restaurant, serving their famous Asia Fantasia platter.

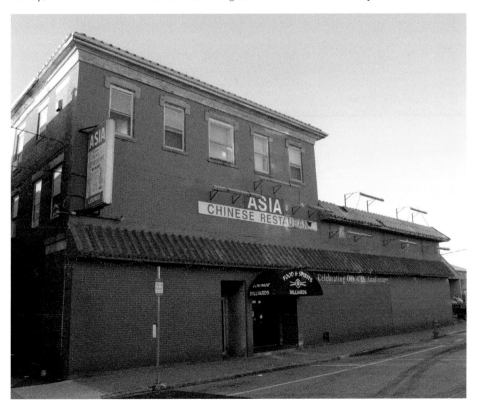

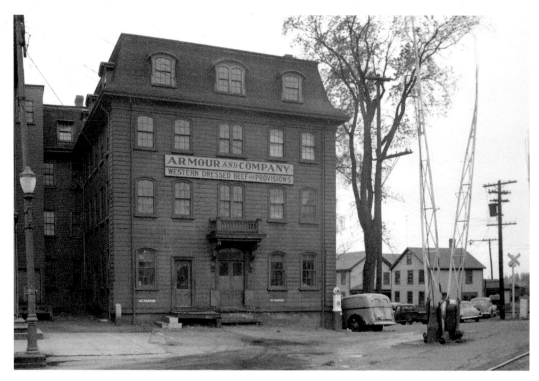

ARMOUR AND COMPANY: Located at the end of Third Street on the corner of Chestnut Street in the 1940s was a wholesale meat packing company offering "Western Dressed Beef" that arrived by train. For many years, Varney Cleaners operated in a new building. It is currently operated by Cleary Drycleaners and Laundromat.

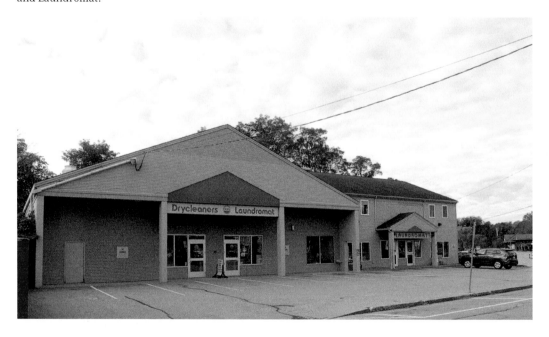

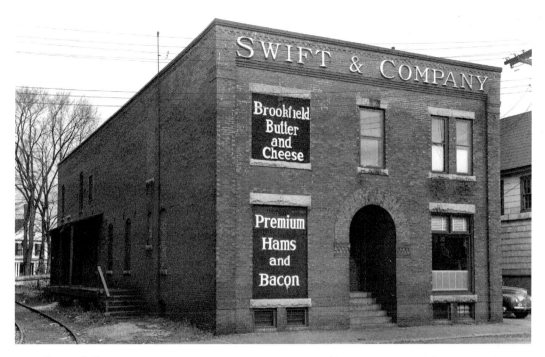

SWIFT & COMPANY: Dover Beef Company was incorporated in 1887 on Second Street. In early 1900, they expanded to 11-13 Fourth Street, specializing in "Hammonds Dressed Beef." In 1921, they became Swift & Company and operated from this location until a new facility was constructed off Knox Marsh Road in 1970. Joe Holmwood owned the property for many years selling unfinished furniture and wallpaper. Today, Cara Irish Pub is the place for a pint of Irish ale and good food.

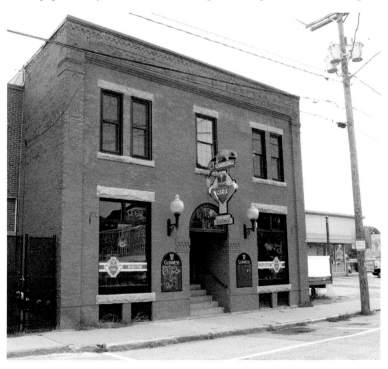

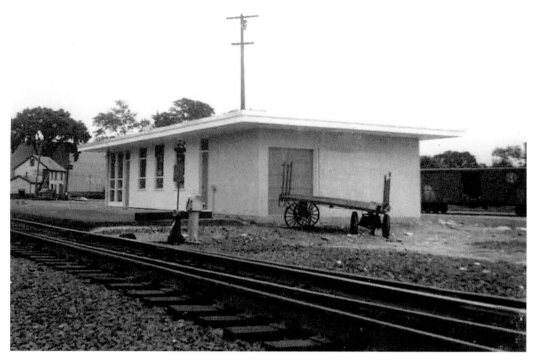

BOSTON & MAINE RAILROAD: The first train arrived in Dover on September 1, 1841, and a two-story brick station was built in 1873. In 1928, the Boston & Maine Portland Division was moved to Dover and a third story was added. Passenger service ended in 1967, the station was demolished, and a small cinder block station was built in the old railyards on Chestnut Street. In 2000, a train station was built in memory of Joe Sawtelle, who donated the land for a transportation center in Dover.

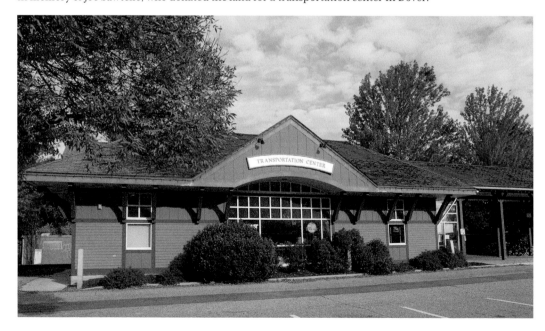

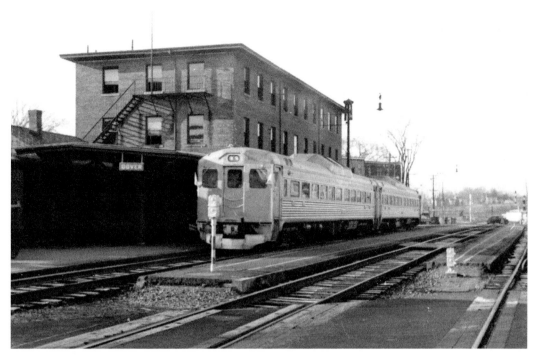

DOWNEASTER COMES TO DOVER: In 1952, the Buddliner diesel car replaced the "Streamliner" and could run a single car as service began to decline. On June 30, 1967, passenger rail service was discontinued. On December 14, 2001, train service returned to Dover and the Downeaster was greeted by Mayor Wil Boc, city officials, and Gov. Jeanne Shaheen.

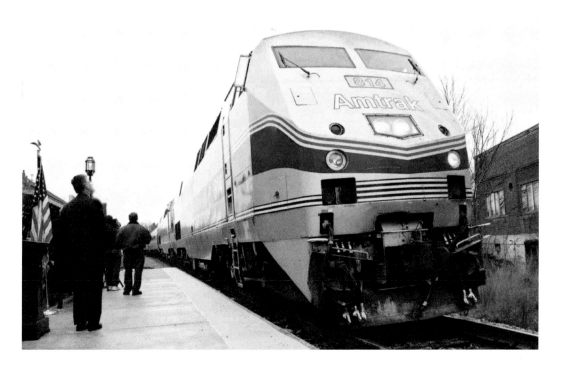

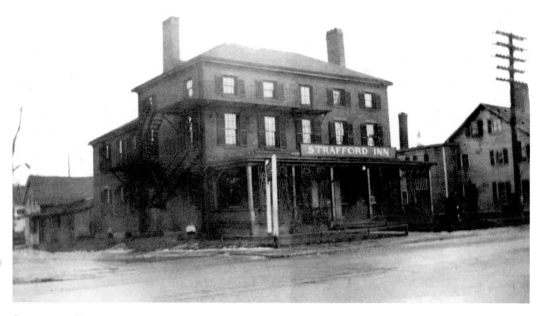

STRAFFORD INN: Located on the corner of Pierce Street and Central, across the tracks from the train station, was the Strafford Inn during the early 1900s. The popular Stoney's Diner served many breakfasts and lunches to the locals at this site in the 1950s-1960s. Today, White Water Car Wash is the place to get a car washed or detailed.

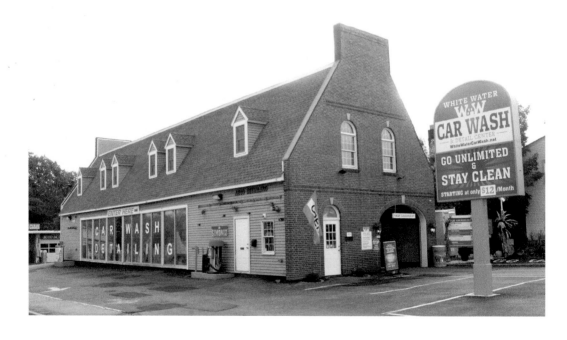

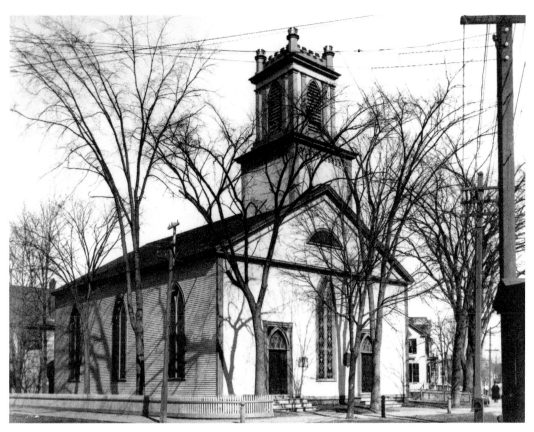

CENTRAL AVENUE FREEWILL BAPTIST CHURCH: Built in 1828 on land given by the Cocheco Manufacturing Company, the church building later becomes Flowers Furniture. It was demolished to make way for the Monarch Diner in the 1960s. Today, Dunkin Donuts starts your day.

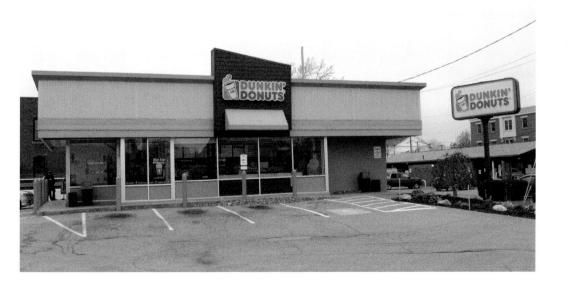

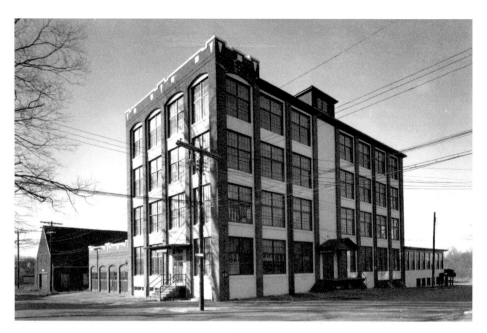

JUDSON DUNAWAY CORPORATION: Mr. Dunaway founded Expello, a moth repellent, in 1928. Around 1940, at his factory on Grove and Fourth Streets, he was producing Vanish Toilet bowl cleaner. Northern Heel Company operated here in 1965, and today the building continues to offer space for small manufacturing companies.

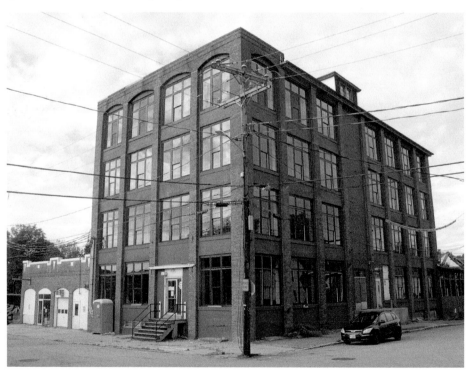

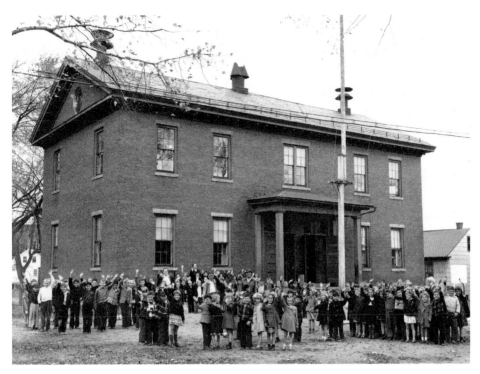

PIERCE STREET SCHOOL: A brick schoolhouse was built in the 1860s on Pierce Street as an elementary school for that neighborhood. Like other small neighborhood schools, Pierce closed in 1958 when the new larger Horne Street School opened. The old school serves today as an office.

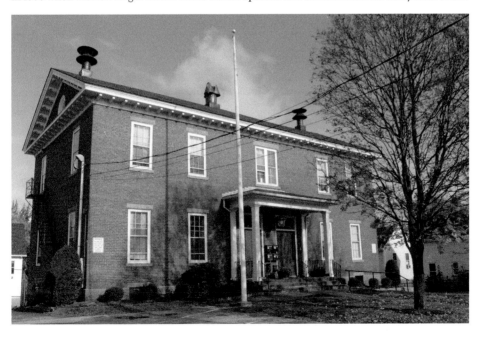

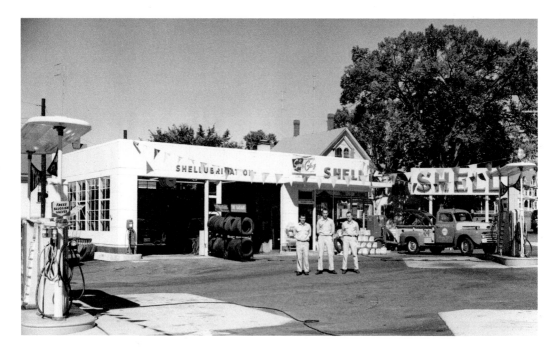

TRIANGLE SHELL STATION: Mike Bailargeon opened a Shell Station at the triangle on Central, Chestnut, and Sixth Streets in 1972. His repair service was so good that he was one of the first to offer "self-service" at the pumps. Renovated into a commercial office building, today the Dover Chamber of Commerce office and Visitor Center are located on this site. The Chamber welcomes businesses and visitors to Dover and sponsors an annual Apple Harvest Day in October.

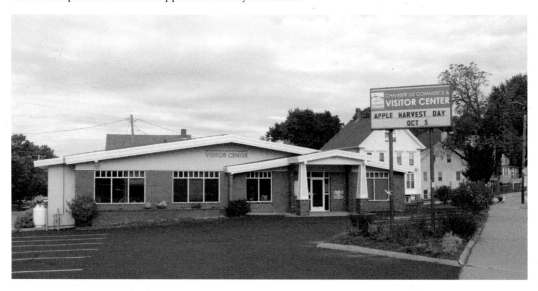

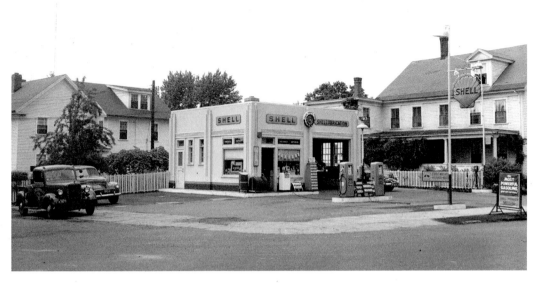

COOKS SHELL SERVICE STATION: Jack Cook operated a single-bay garage on the corner of Milk Street in the 1940s early 1950s. The site today is Gold Rush Coin & Jewelry, Salon Di Diosa hair care and coloring, and Simply Clean dry cleaner.

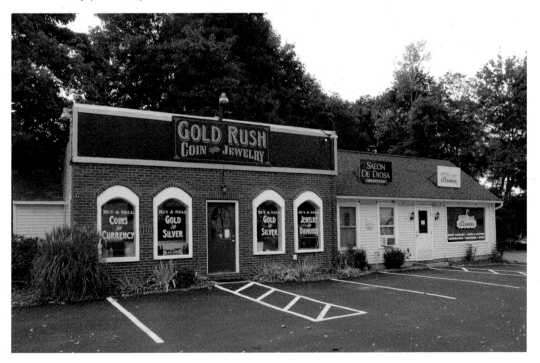

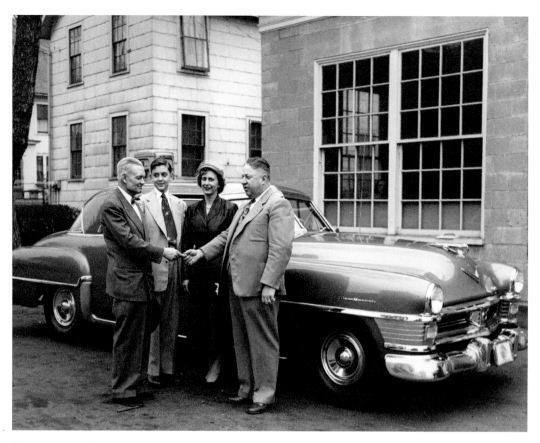

WENTWORTH GARAGE: Ray Wentworth sold and serviced Chrysler automobiles at his 6 Milk Street garage. In 1951, Gov. Sherman Adams received a new car from Wentworth, who also operated the Wentworth Bus Lines in Dover. In 1965, this became Kimball's Garage and today is home to Blier Flooring.

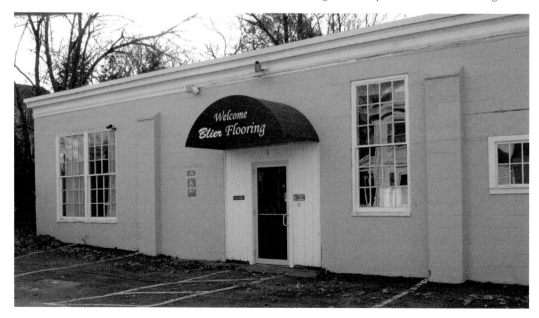

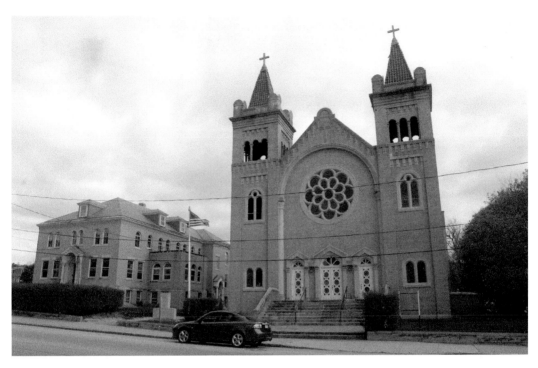

ST CHARLES BORROMEO CHURCH: The original wooden church located on Third Street was destroyed by fire in 1932. A year later, St Charles new church on Central Avenue was dedicated and served the French community until 2017, when the church was demolished to make room for the new Bradley Commons building for workforce housing and non-profit office space.

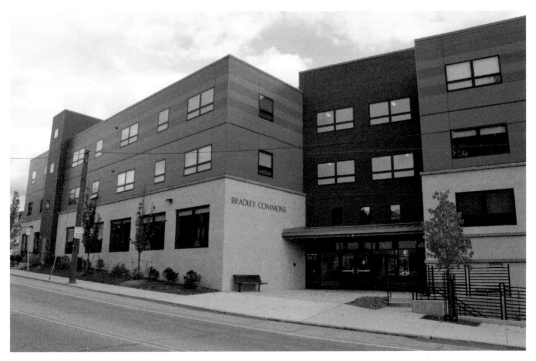

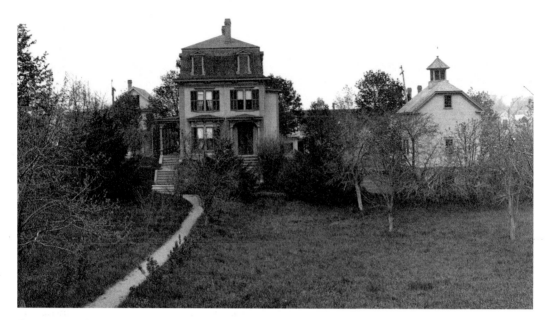

CHURCH OF CHRIST SCIENCE: After several years of meeting in private rooms, the Brown Shackley Estate at 605 Central Avenue was purchased in 1913. The property was renovated and used for worship until October 2012, when the Center for Assessment moved from the Washington Street Mill to the newly renovated office space offering educational assessment and accountability to schools around the country.

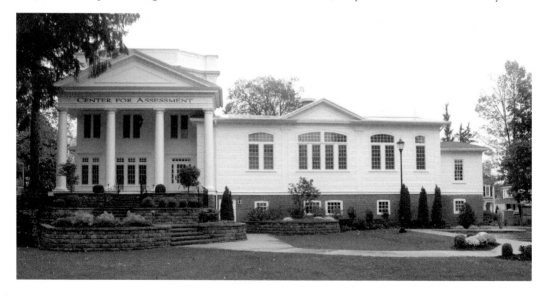

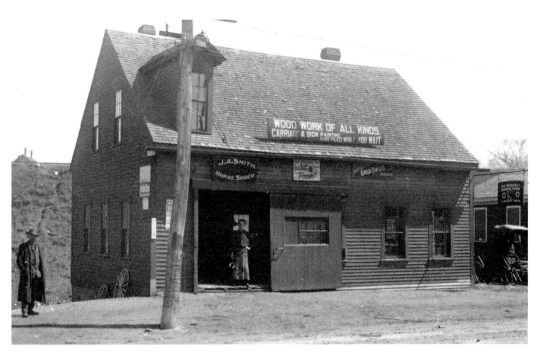

RED'S SHOE BARN: J. A. Smith did horse shoeing and ran a carriage shop and carriage painting service in the late 1800s-early 1900s on Broadway in Dover. After a couple years selling factory seconds from local shoe shops out of a station wagon, Peter "Red" Murray converted the old blacksmith barn into a shoe barn in 1958. In 2008, his son Patrick celebrated a fiftieth anniversary at the now famous Red's Shoe Barn.

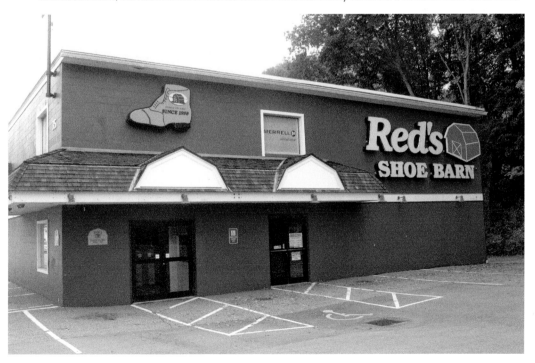

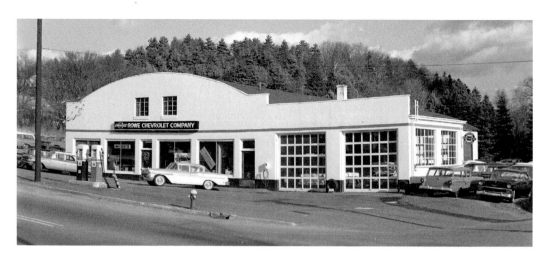

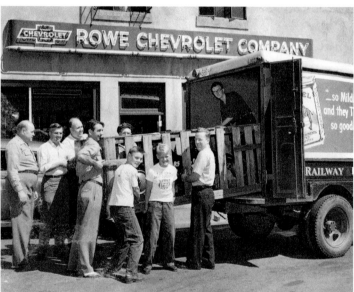

ROWE CHEVROLET:
Located on the corner of
Oak Street and Central
Avenue, Rowe Chevrolet
was the sponsor of the
Soap Box Derby, held
every year on the hill in
front of the dealership.
In 1949, "champ" Bruce
Dearborn is given help
loading his racer onto a
Railway Express truck
on its way to Akron,
Ohio. Today, Kennebunk
Savings and Wentworth
Douglass Express Care
operate from a modern
building.

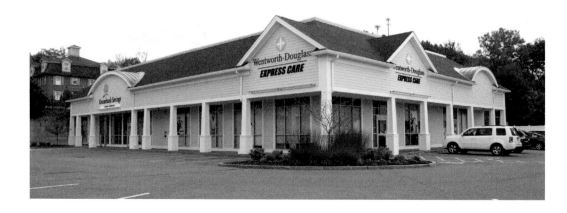

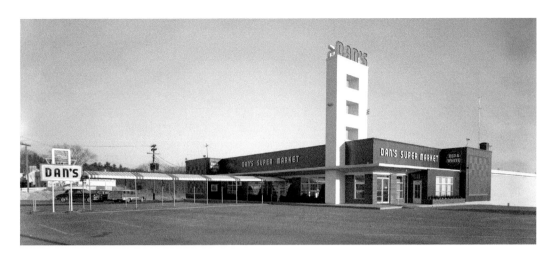

DAN'S STAR MARKET:
Managed by Howard
Cummings in 1959, Dan's
was the most popular food
store in the Dover area with
aisles of check-out registers
and weekly specials.
Woodski's Restaurant was
located here in the 1990s and
today, Black Dog Car Wash.

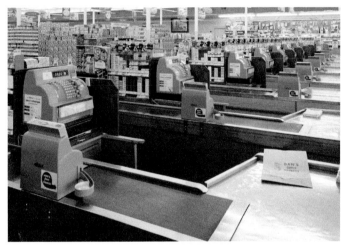

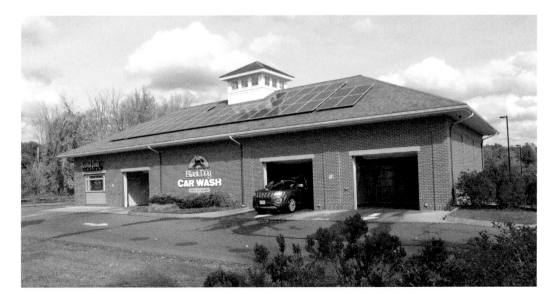

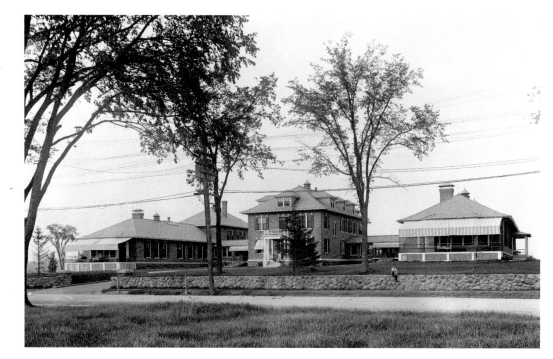

WENTWORTH HOSPITAL: The hospital was founded in 1904 when Arioch Wentworth willed the city of Dover $100,000 to erect a forty-bed cottage style city hospital. Later, in 1922, the Rollins Building was added, a gift from Edward Rollins to be used as a nursing school. The school closed in 1952 and the building was used as medical offices. The cottage buildings were eventually removed with major renovations, and the 1960s saw a new brick Central Avenue entrance to receive visitors.

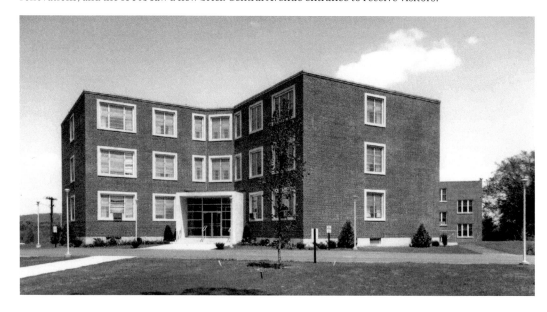

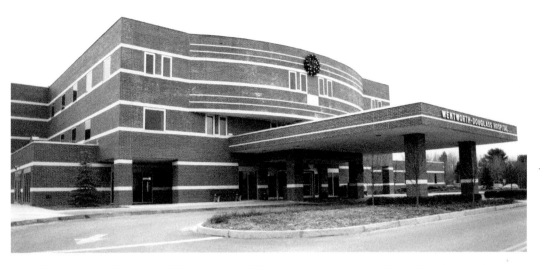

WENTWORTH DOUGLASS HOSPITAL: In 1982, the hospital separated from the city organizing as a non-profit community hospital. In 1998, a new main entrance was opened at the rear of the hospital and again, in 2002, a 43,000-square-foot outpatient center was added with a new separate entrance. On December 13, 2012, a gala event in the new community conference center allowed guests to see the new four story Garrison Wing, officially opening to the public in January 2013.

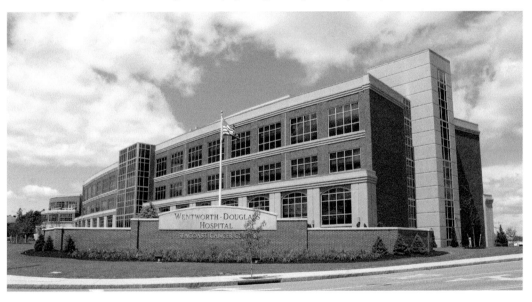

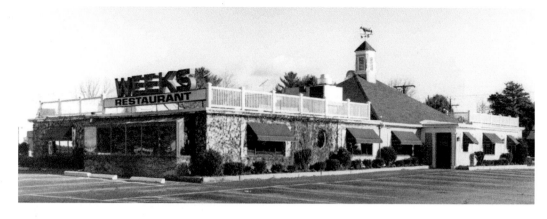

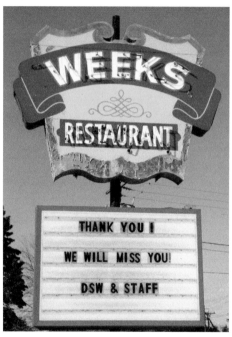

WEEKS RESTAURANT: In 1964, David Weeks purchased Big Dipper Ice Cream Shop and added a fifty-seat restaurant. When Weeks closed in 1995, the restaurant was a 250-seat family restaurant. It was once a must stop for presidential candidates, and one of the first area restaurants to feature a non-smoking room. In 1995, Dave was recognized as Citizen of the Year for all his contributions to the community over three decades. In the spring of 1996, a Chili's Restaurant opened on the site now called Weeks Crossing.

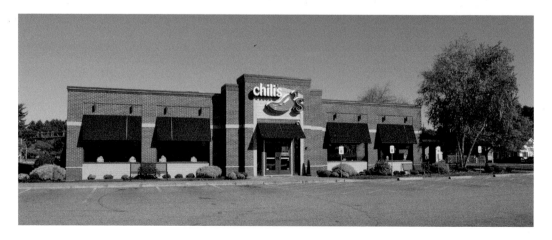

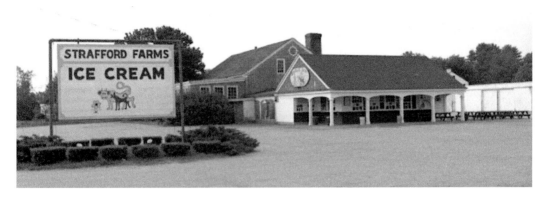

STRAFFORD FARMS RESTAURANT:
In 1939, the Rollins family and Leo Allen built this building to operate a wholesale-retail milk business. The milk was purchased from local farms. In 1941, ice cream was offered, and in 1957 a small grill was added. The milk business sold in 1963. Today Leo's grandchildren operate a full-service restaurant and lounge and are still making homemade ice cream.

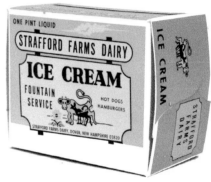

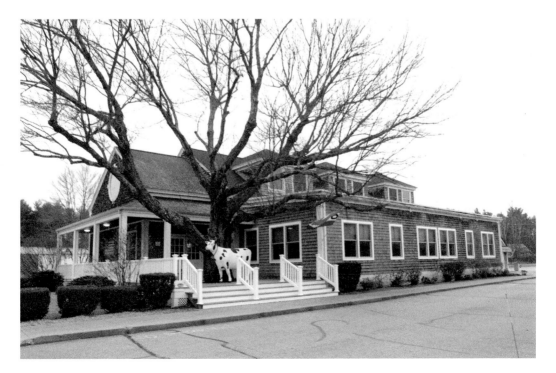

ACKNOWLEDGMENTS

Credit and recognition for these early pictorial history books must be given to the early photographers whose negatives are used to reproduce these images of the past. Since the introduction of the photographic process in 1839, we no longer rely on paintings on canvas to capture a portrait of a family member or a scenic landscape. Many of these early cameramen did not realize at the time that they were recording a piece of history each time they clicked the shutter. Whether an historic event, or a local street scene, that moment was captured for future generations to see and enjoy. In the early days of photography, it would require a photographic artist, with special talent and the ability to prepare the photographic plates and capture just the right exposure. Once roll film was introduced in those little box Brownie cameras, everyone, even children, were now able to click that shutter and capture their little piece of history. Film would now be developed and printed commercially, no longer requiring the photographer to have a darkroom, or be involved with dangerous chemicals. To quote George Eastman: "You Press the Button, We Do the Rest." Dr. Land and his instant Polaroid was a step closer to today's digital photography. Today photographs are captured on our telephones with instant results at the press of a button.

A special recognition goes to the members of the former Dover Heritage group and the Historical Society (Northam Colonist) for twenty-five years of historical neighborhood walks and research. Robert Marston, Tom and Fran Wells, and Bob Whitehouse, all local historians no longer with us, inspired me to get involved and help preserve and share local history. The camera allowed me to capture small pieces of Dover's history over the years during urban renewal, fires, ribbon cuttings, new construction, celebrity and presidential visits. Having the opportunity to acquire and preserve the negatives of earlier Dover photographers like Henry Horton, George Wentworth, M. J. Smith, A. Thornton Grey, J. Edward, and Andrew Rivers made this book possible.